MICHAEL NEUGEBAUER VERLAG AG NORTH-SOUTH BOOKS

THE ART OF IVAN GANTSCHEV

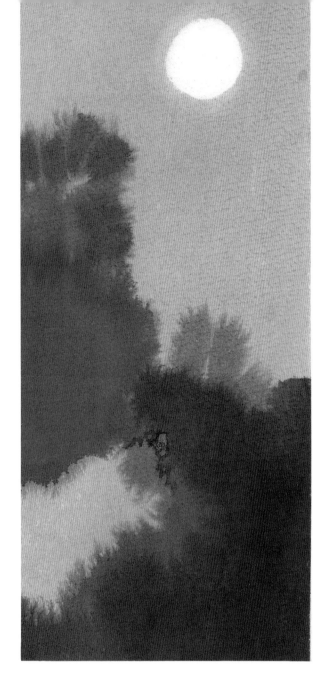

1 Watercolour, 17 x 8cm

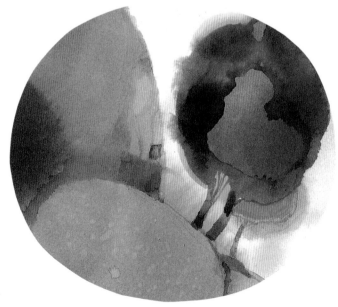

2 Watercolour, 9 x 9cm

THE SUN, THE MOON AND THE OTHER THINGS

DIE SONNE, DER MOND UND DIE ANDEREN DINGE

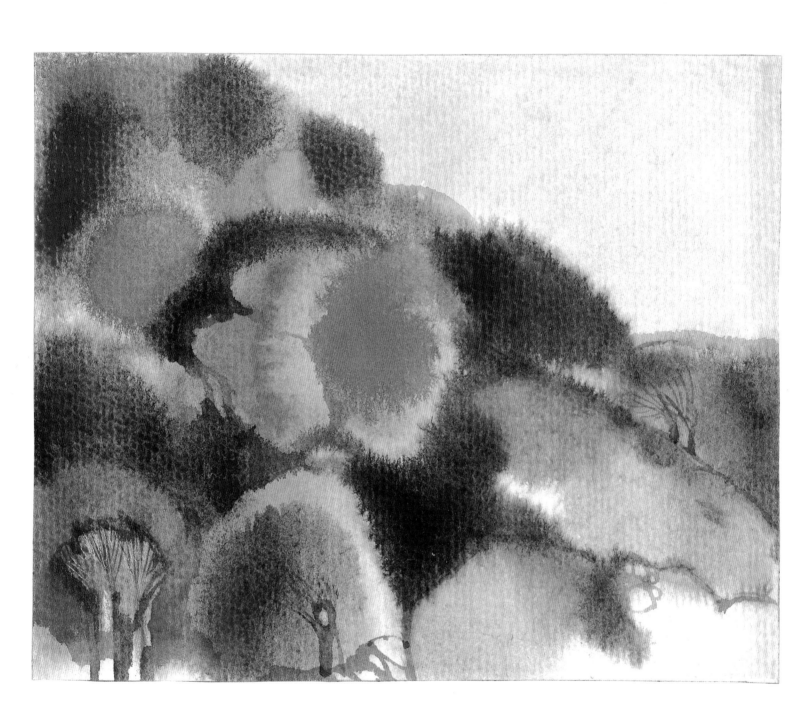

3 LANDSCAPE IN AUTUMN / watercolour, 18 x 22cm

The Art of Ivan Gantschev

The world is wonderful and I want to paint it again and again. We walk through this world with our three-dimensional faculty of thought. Some say that there is a fourth dimension. Is it possible to make the invisible visible by painting the visible, concrete things? Is that the fourth dimension or is that art?

Die Welt ist wunderschön und ich möchte sie immer wieder malen. Wir durchwandern diese Welt mit unserem dreidimensionalen Denkvermögen. Man sagt, es gäbe eine vierte Dimension. Wäre es möglich, durch Malen von sichtbaren, gegenständlichen Dingen das Unsichtbare sichtbar zu machen? Ist das die vierte Dimension oder ist das Kunst?

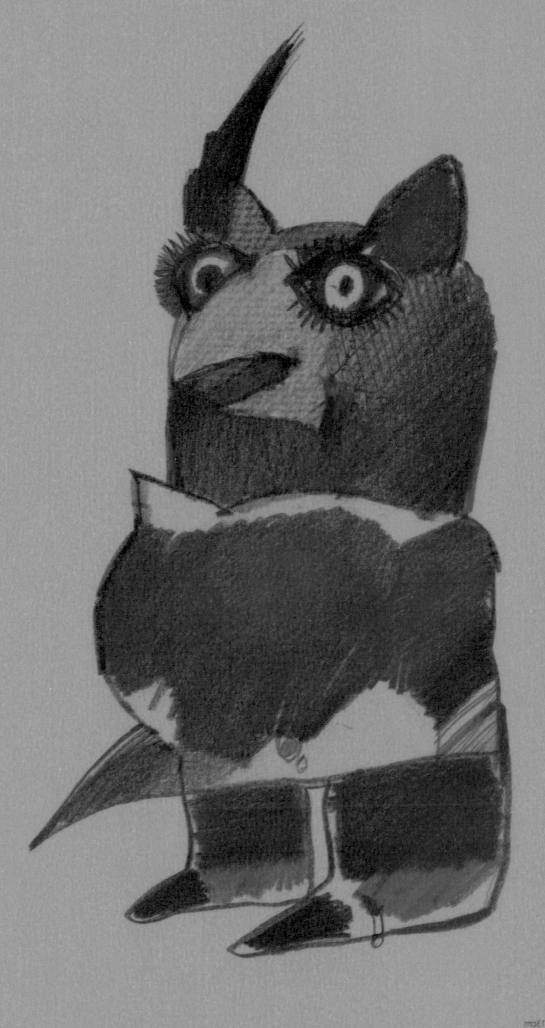

4 THE GUARDIAN / coloured pencil, 24 x 13cm

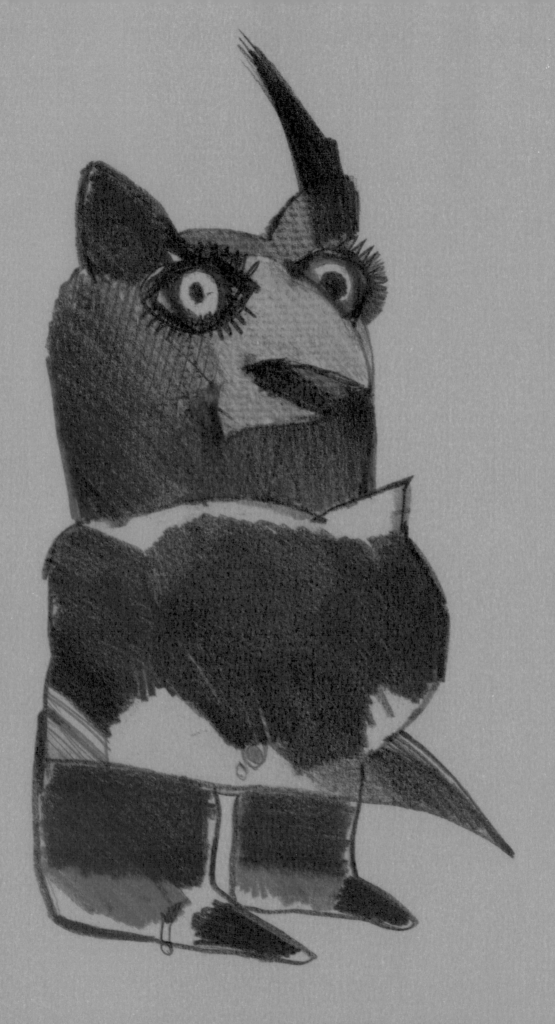

4 THE GUARDIAN / coloured pencil, 24 x 13cm

5 BEYOND / pencil and graphite, 35 x 50cm

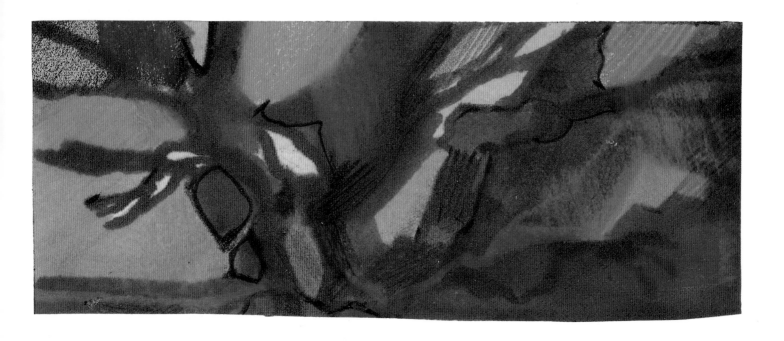

6 FOREST IN BLUE / watercolour and coloured pencil, 9 x 23cm

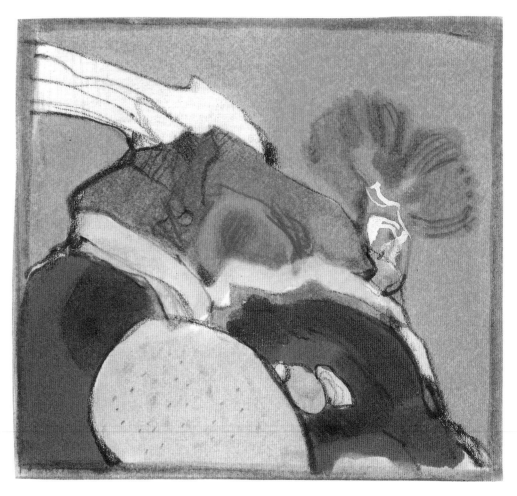

7 LANDSCAPE / watercolour and pastel, 35 x 40cm

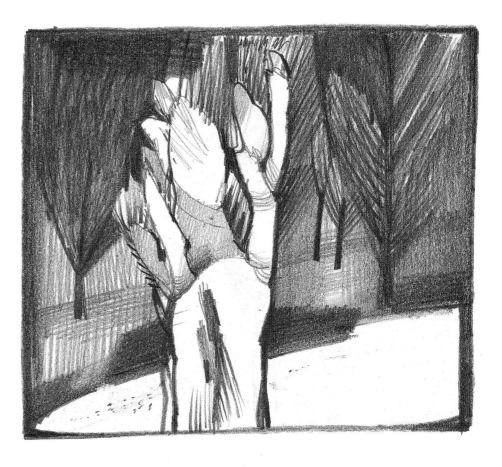

8 Pencil Drawing / 11 x 12cm

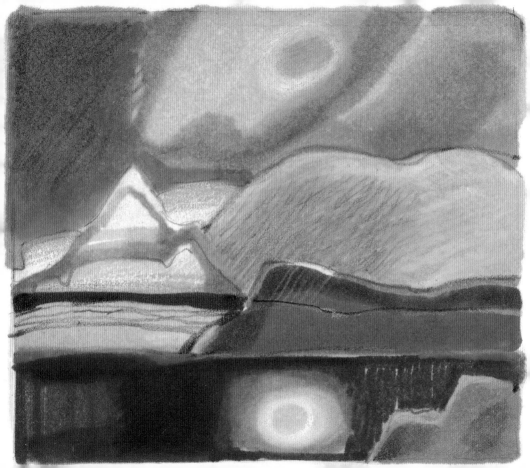

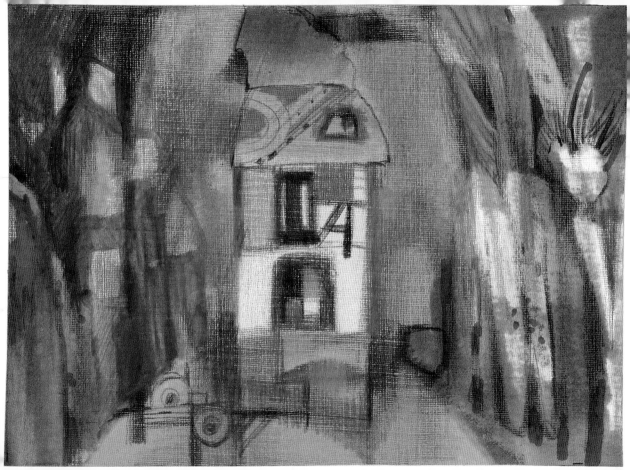

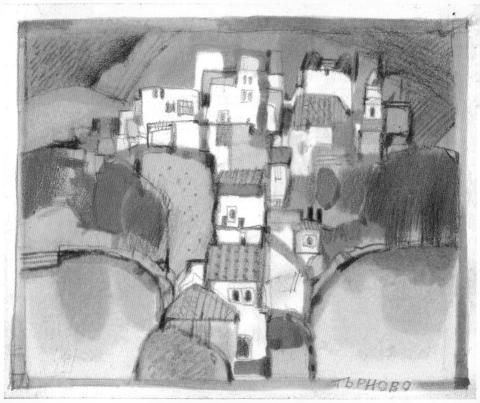

ТЪРНОВО

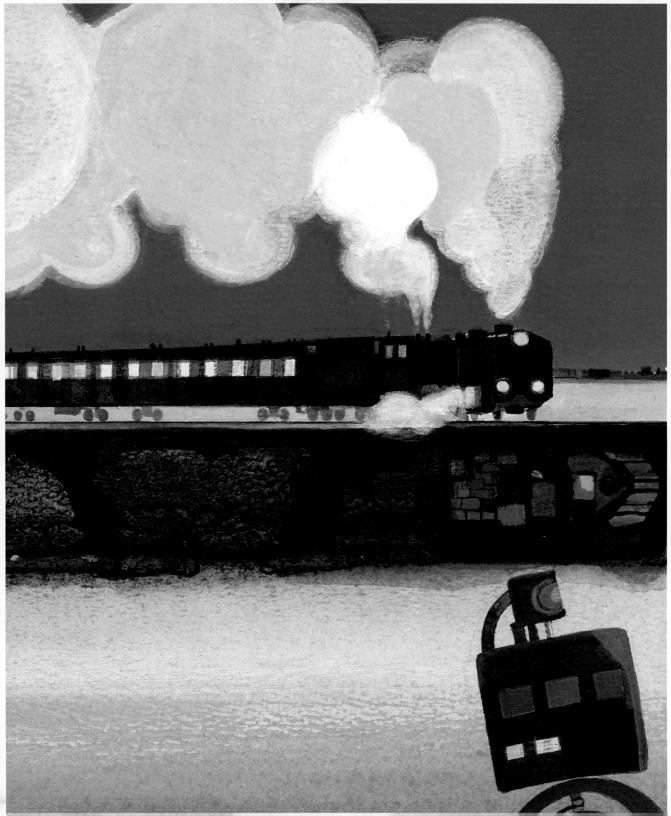

3 Ivan Gantschev with his cat

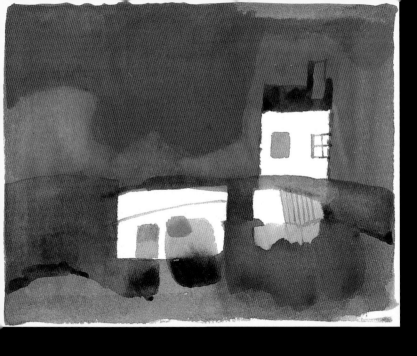

15 THE HOUSE / watercolour, 9 x 19cm

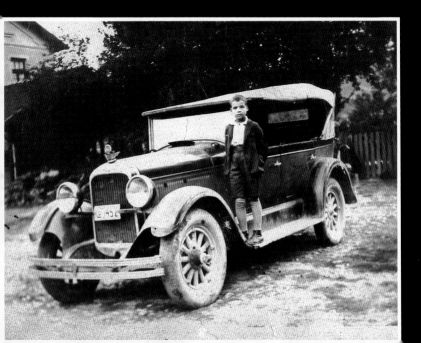

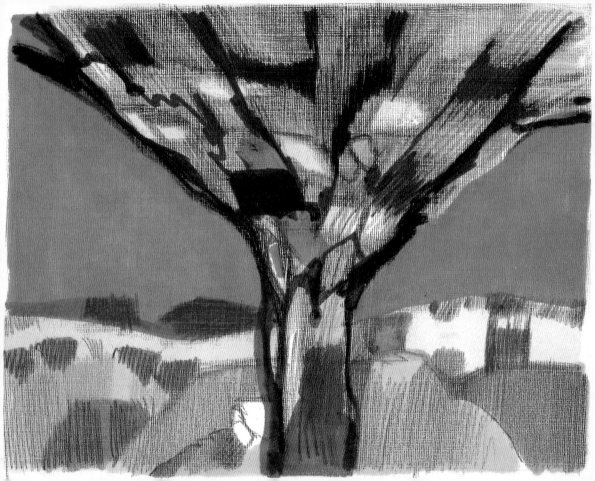

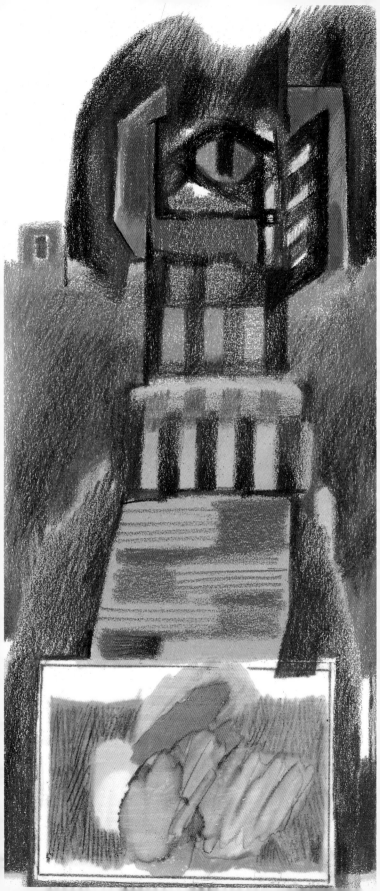

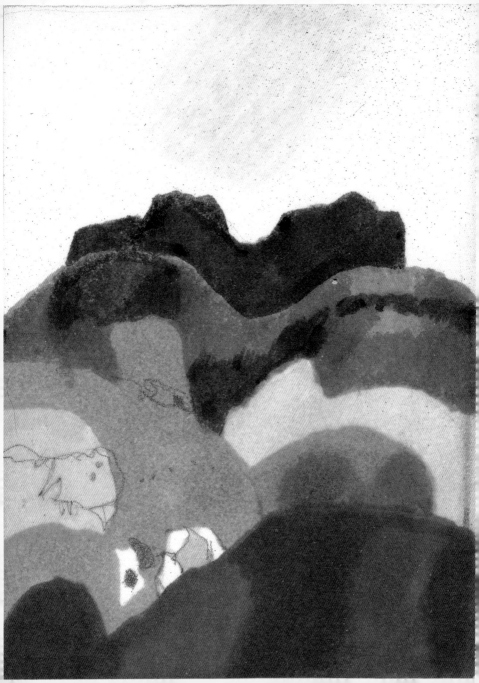

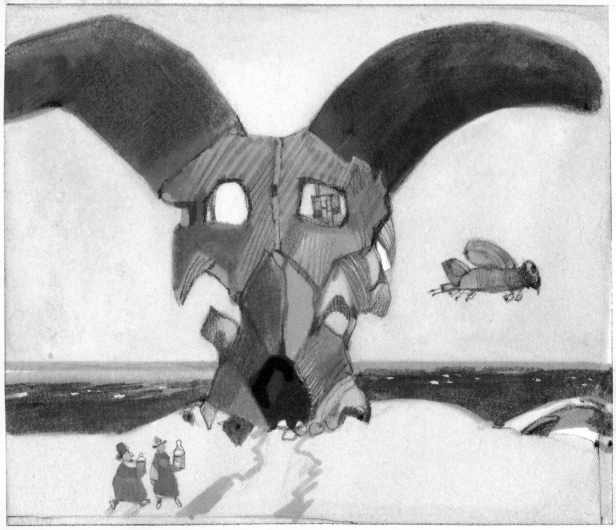

23 Amigo Mio Amigo / pencil, 9 x 9cm

24 La Primadonna / pencil, 9 x 9cm

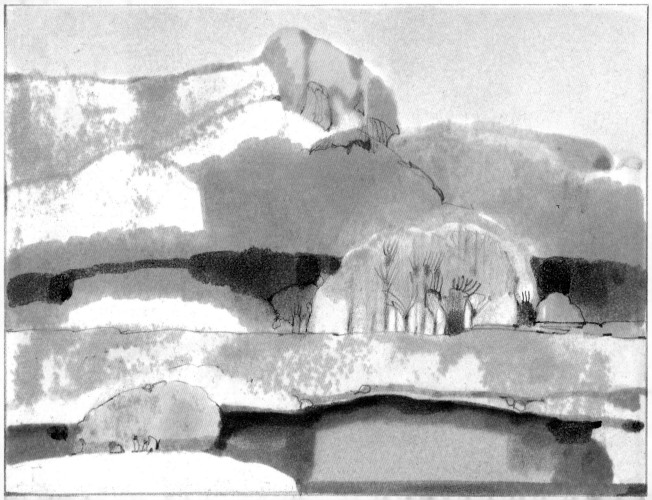

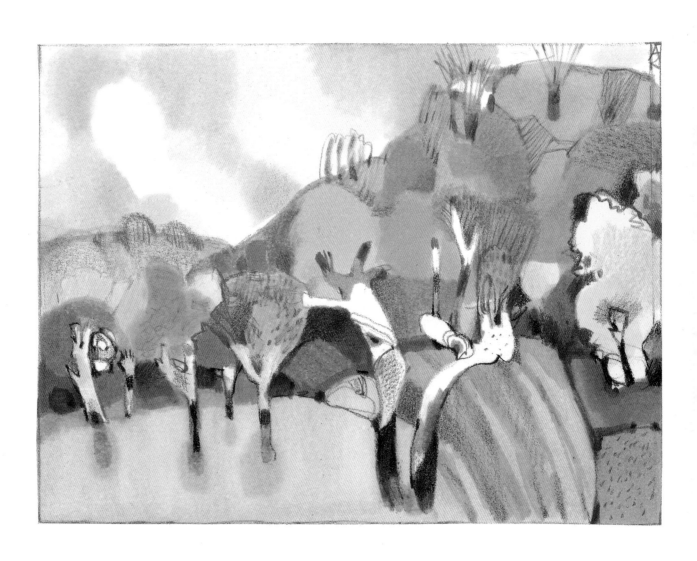

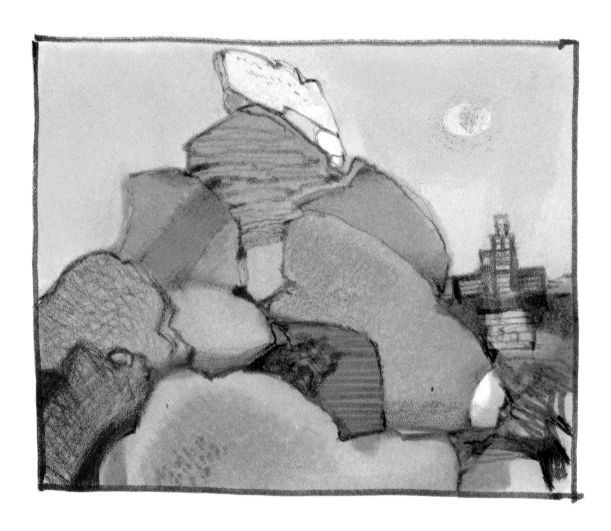

27 SOMEWHERE / pastel and watercolour, 30 x 40cm

28 I, Hortensia / coloured pencil, 5 x 7cm

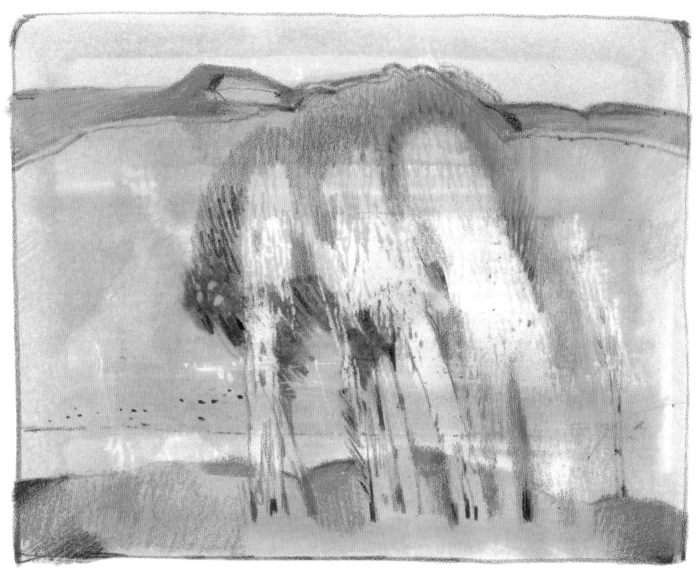

29 Trees at the River / watercolour and pastel, 15 x 19cm

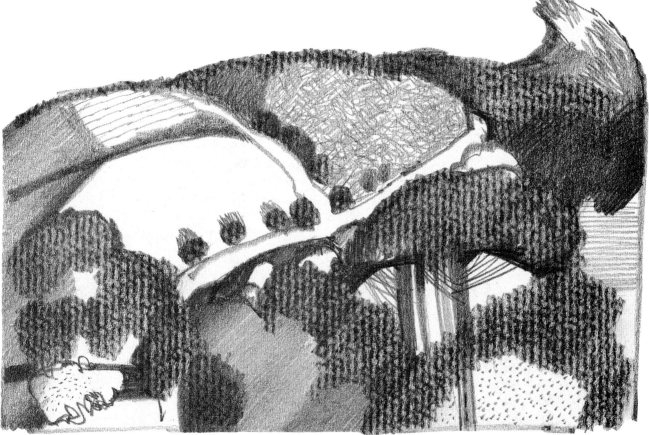

30 Pencil Drawing / 15 x 18cm

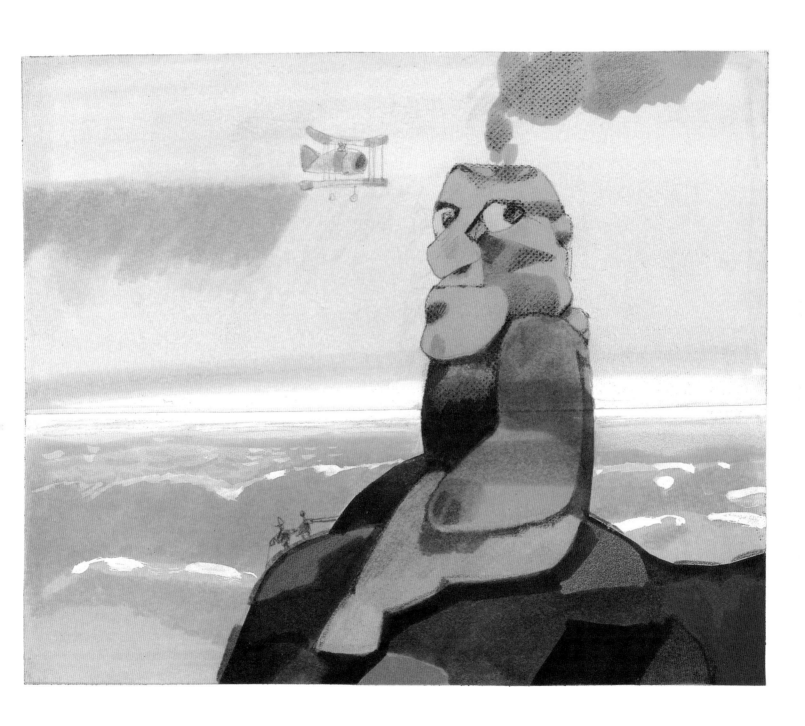

Black and white bind up all colours that
come between them, even those which do
not harmonize. This is the visual language
of the decorators and the propagandists,
blunt and purposeful.
Red and green means a fair with a brass
band. The language of the poets is more
difficult, as it must use fine shades of many
colours without tirades and propaganda.

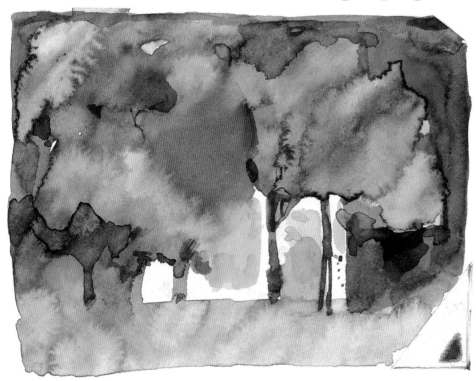

Schwarz und weiß dazwischen binden alle
Farben, auch diejenigen, die sich nicht ver-
tragen können. Das ist die Sprache der
Dekorateure und der Propagandisten.
Rot und grün ist Volksfest mit Blasmusik.
Schwieriger ist die Sprache der Poeten.
Die feinen Farbabstimmungen ohne Tiraden
und Werbetrommel.

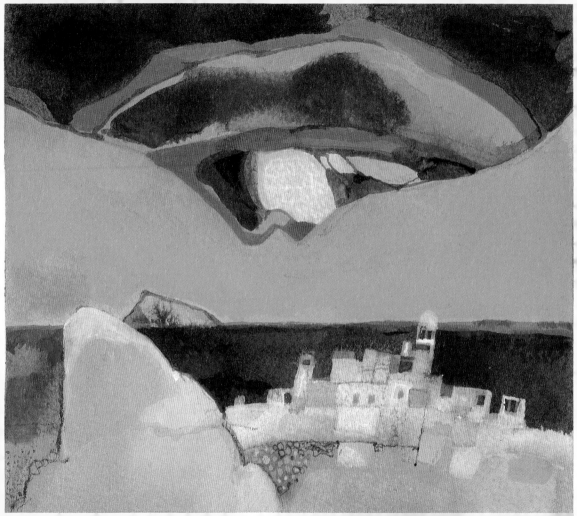

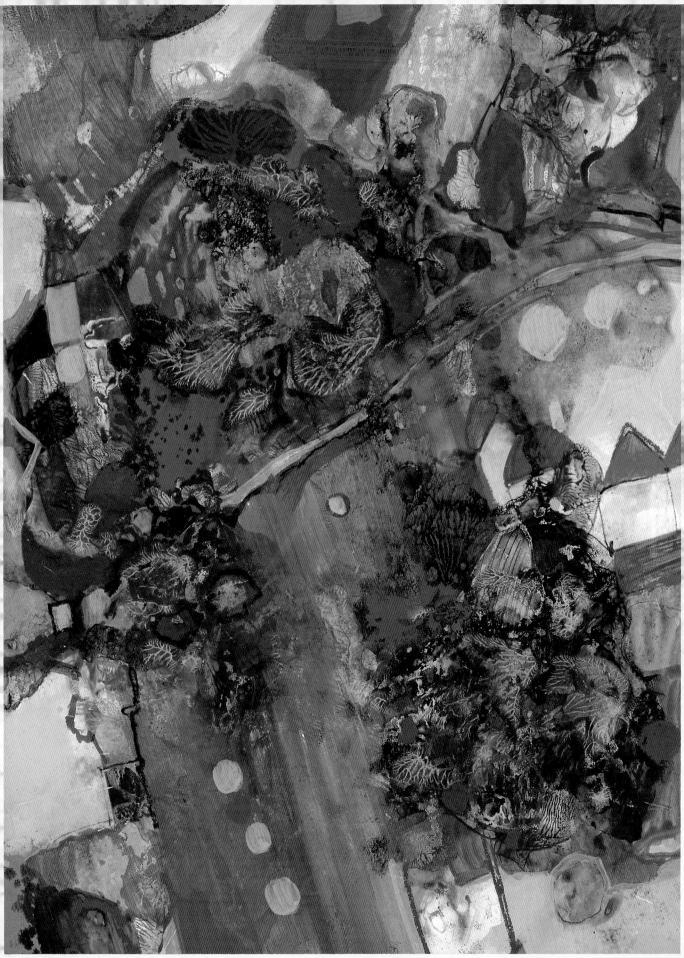

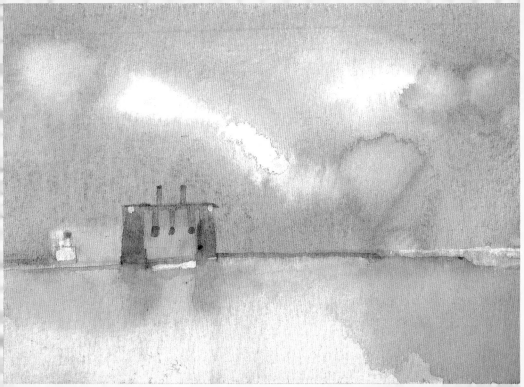

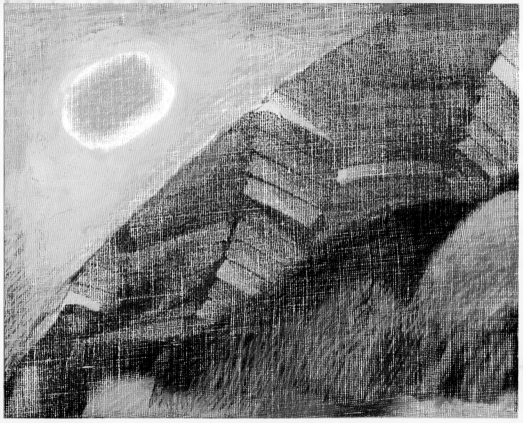

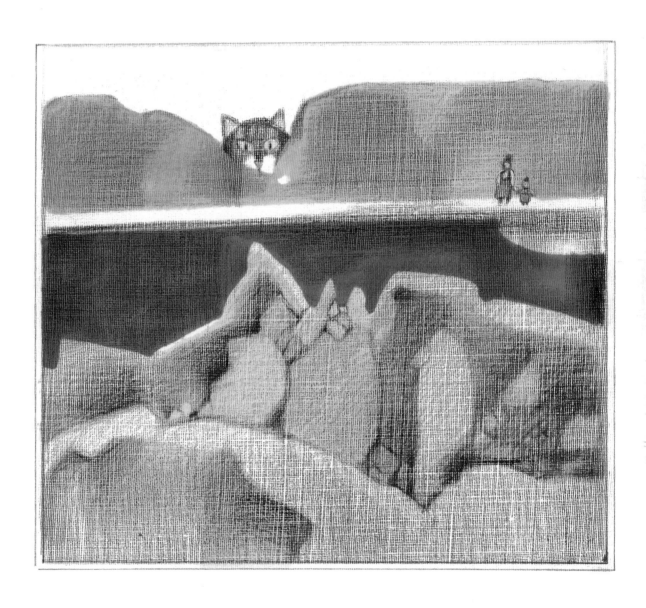

37 THE CAT / coloured pencil on canvas, 14 x 16cm

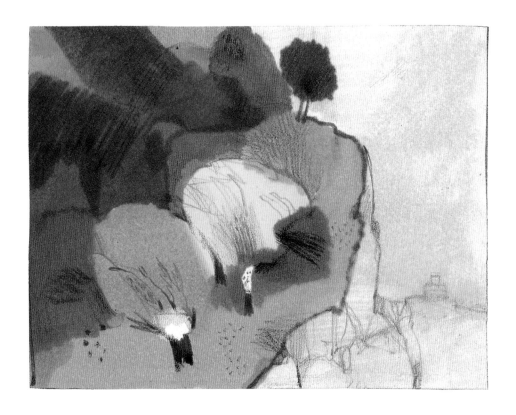

38 Autumn / watercolour, 16 x 20cm

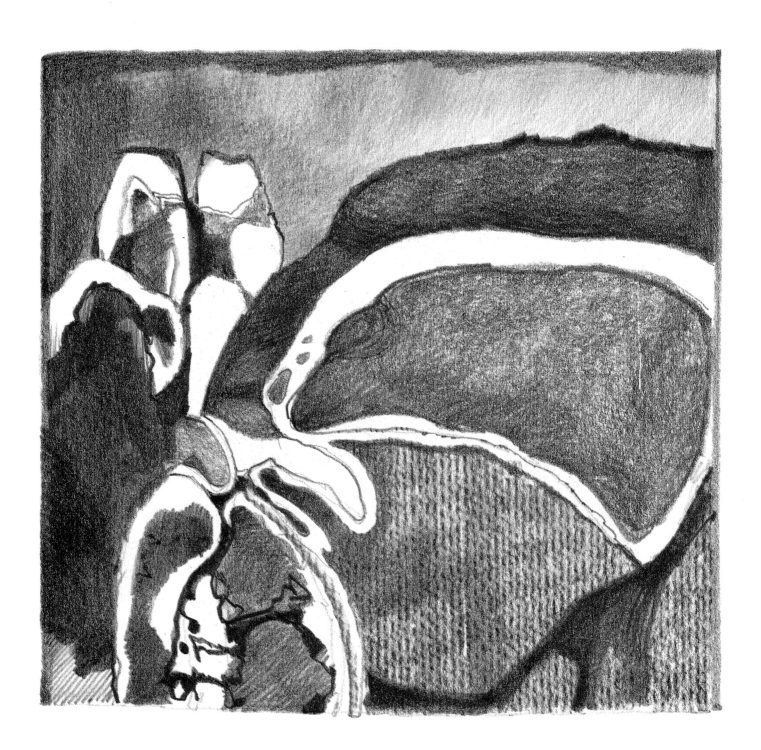

I have painted with water-colours for as long as I can remember. With oils or acrylics, colours can be controlled, many elements in a picture can be changed, and often you do not know the limits of a work in progress. The water-colour, however, does not tolerate any regulation, no worked out proportions of circle to square, no elaborate preconceptions. It is full of imagination – unpredictable like nature, but with its own logic and order. I think the water-colour is completely unsuitable for the skilled crafts or the applied art. It would work in a commercial application only if one used the water-colours to dye forms or drawings. But then it wouldn't be a genuine water-colour. The medium of water-colour has caused controversy among the art critics because it cannot be categorized and assigned to a certain genre. How dreadful! The water-colour is completely irrational.

Mit Aquarellfarben male ich, solange ich denken kann. Alle Farben kann man steuern, und vieles ändern und oft kennt man nicht die Grenze. Das Aquarell aber verträgt keine Gestaltung und keine klugausgedachten Verhältnisse zwischen Kreis und Quadrat. Es ist phantasievoll und unberechenbar wie die Natur, aber mit eigener Logik und Ordnung. Das Aquarell ist, glaube ich, vollkommen ungeeignet für das Kunsthandwerk oder die angewandte Kunst. Sei es, man benützt die Aquarellfarben um Formen und Zeichnungen zu färben. Aber das wäre wohl dann kein echtes Aquarell. Das Aquarell ist imstande, auch einige Kunstkritiker in Konflikt zu bringen. Da man es schwer in eine bestimmte Kunstrichtung einordnen kann, gibt es für das Aquarell keine Schublade. Wie schrecklich! Es ist vollkommen irrational.

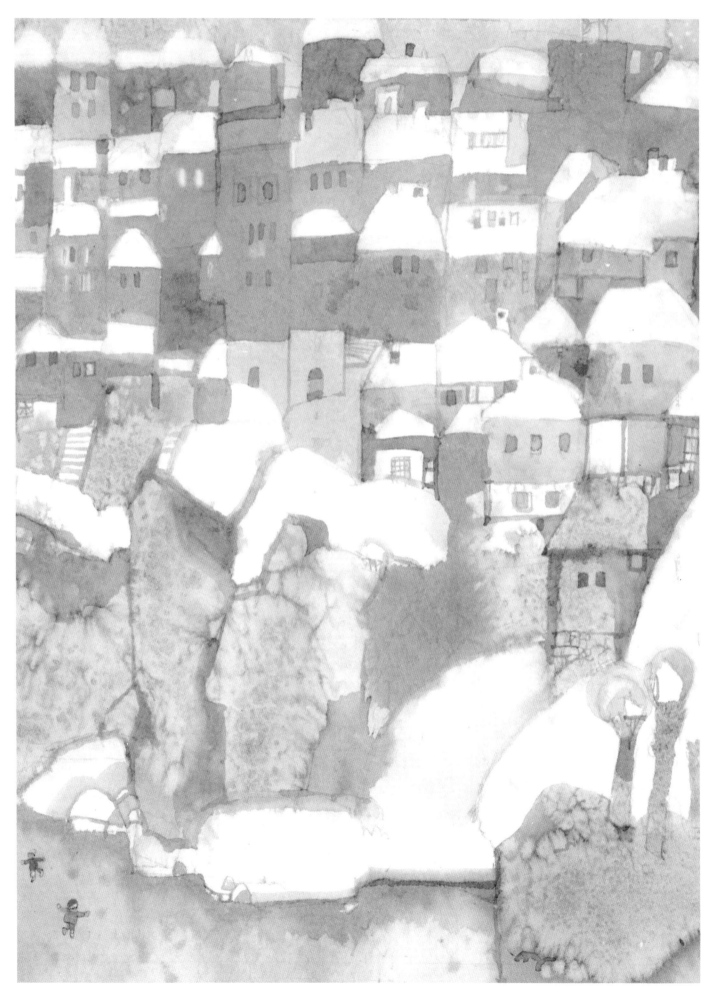

41 THE STRANGER / Book Illustration / watercolour, 21 x 27cm

LA POLIZIA DEL ARTE is the collective name for all institutions which act as guards to see that art and artists follow a decent and constructive path. Degenerate art is often talked about. It has always existed and it will always exist in one form or another. Why? Because La Polizia del Arte always adjusts its mission to the existing political and economic standards in order to keep the gap between ideology and profit from becoming too big.

LA POLIZIA DEL ARTE ist ein Sammelbegriff von allen Institutionen, die dafür sorgen, daß Kunst und Künstler in anständige und nützliche Wege geleitet werden. Man spricht oft von entarteter Kunst. Die gab es immer und wird es immer geben – in gewisser Form. Und zwar deshalb, weil LA POLIZIA DEL ARTE sich nach den bestehenden politischen oder wirtschaftlichen Normen richtet, um zu vermeiden, daß die Kluft zwischen Ideologie und Profit zu groß wird.

43 LANDSCAPE / watercolour, 9 x 11cm

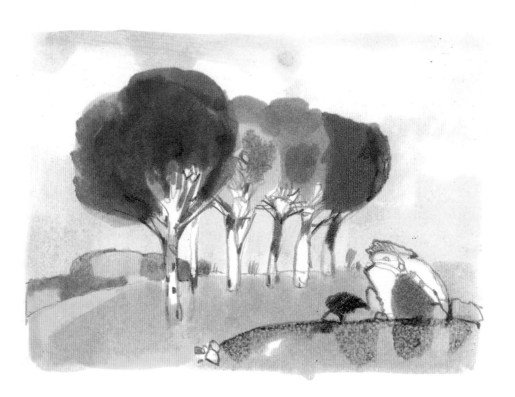

44 LANDSCAPE / watercolour, 9 x 13cm

Some say, if you want to paint a good water-colour, you have to stand knee-deep in water. I always paint on wet paper. It is a fascinating play between wet and dry, soft and hard. I like to be surprised and pulled in. One really has no choice, for the water-colour does not tolerate any authoritarian action anyway.

Man sagt, wenn jemand gutes Aquarell malen möchte, muß er bis zu den Knien im Wasser stehen. Ich male immer auf feuchtes Papier. Es ist ein faszinierendes Spiel zwischen naß und trocken, zwischen weich und hart.
Ich lasse mich gerne überraschen und hineinziehen. Das Aquarell duldet sowieso keine autoritären Handlungen.

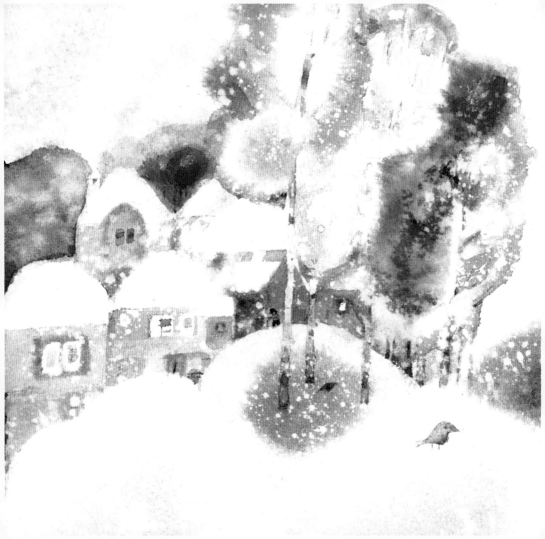

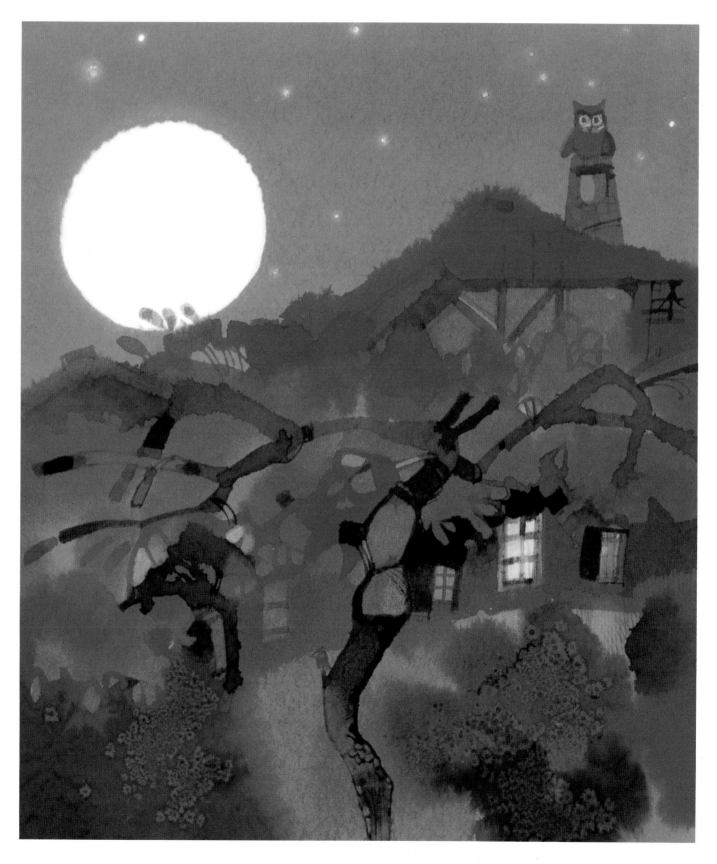

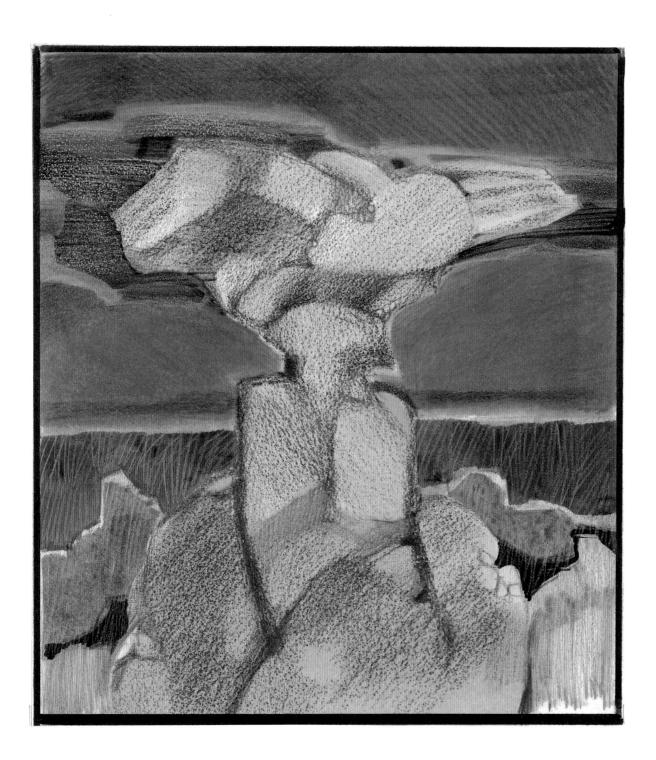

47 MEXICO / mixed media, 20 x 18cm

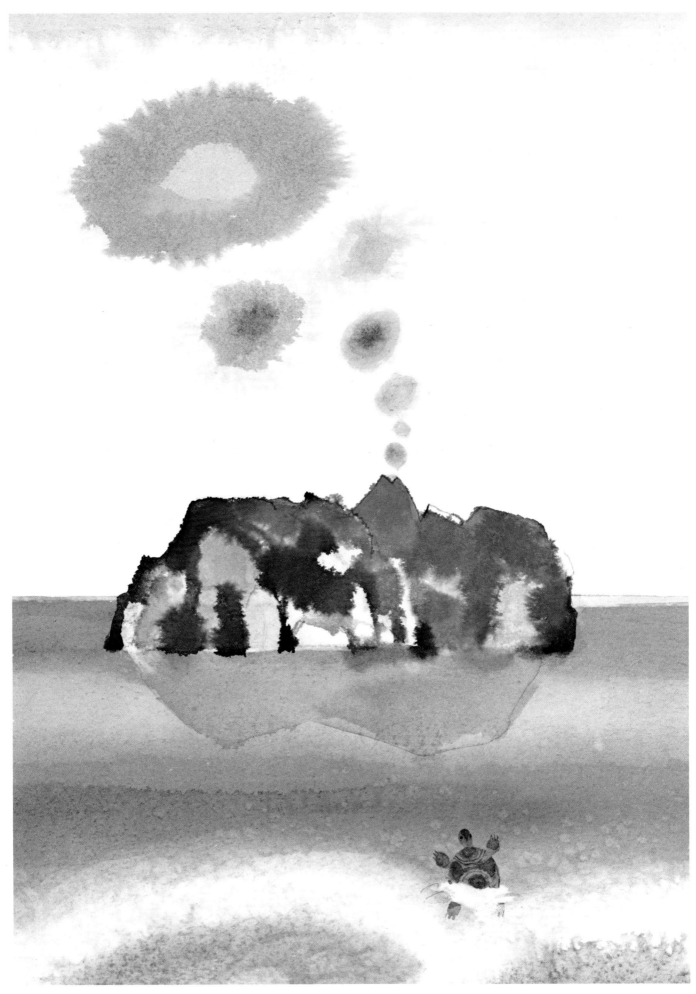

48 THE VOLCANO / Book Illustration / watercolour, 49 x 29cm

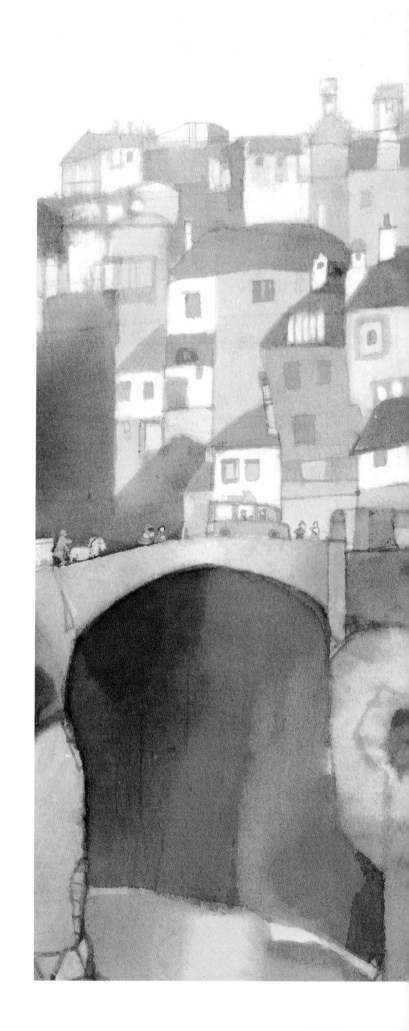

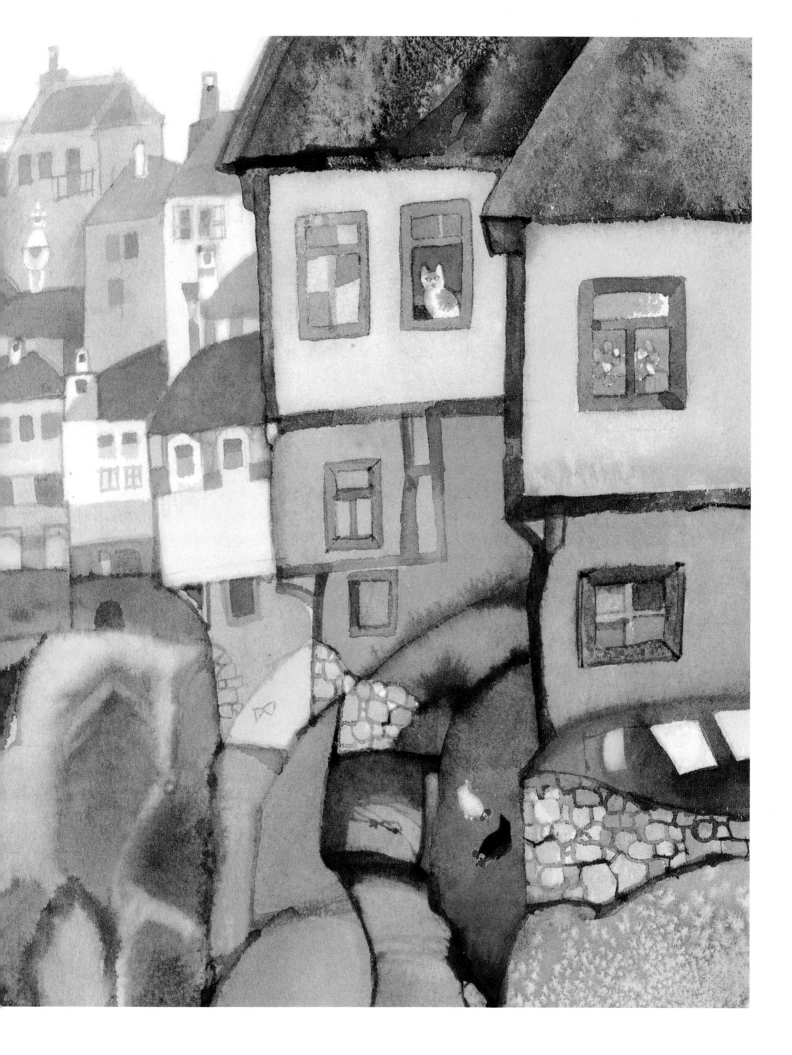

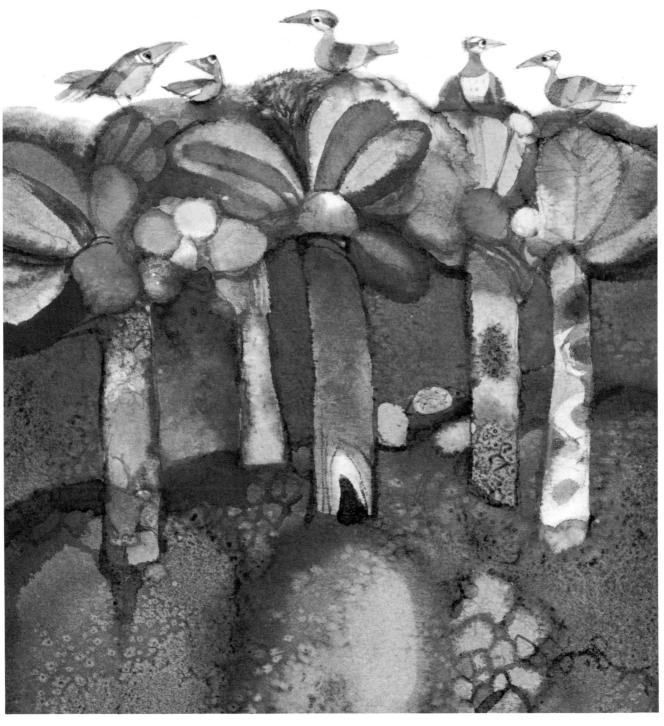

51 THE VOLCANO / Book Illustration / watercolour, 43 x 29cm

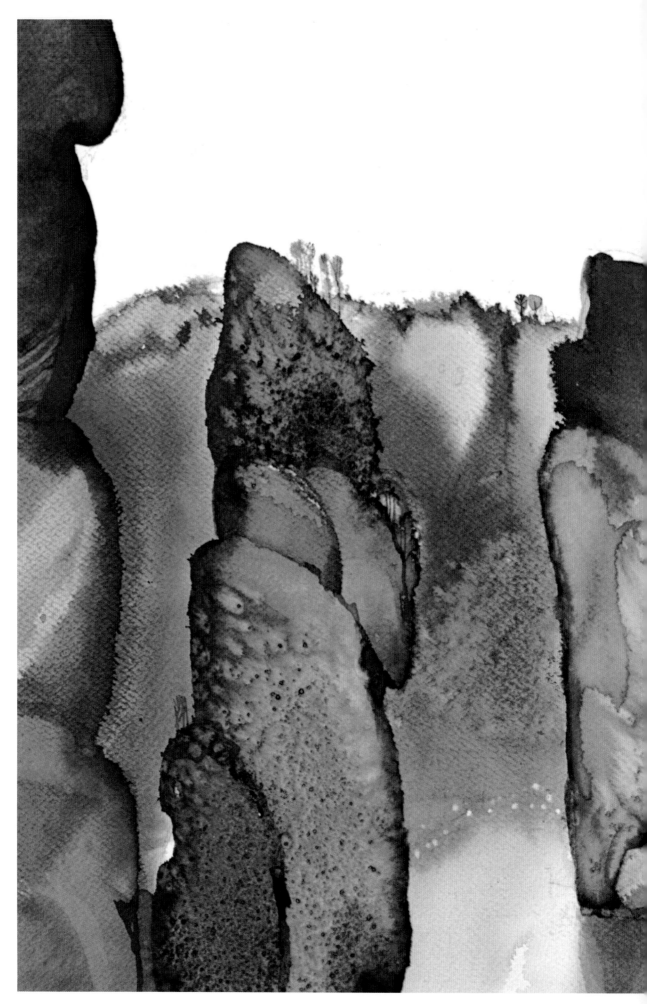

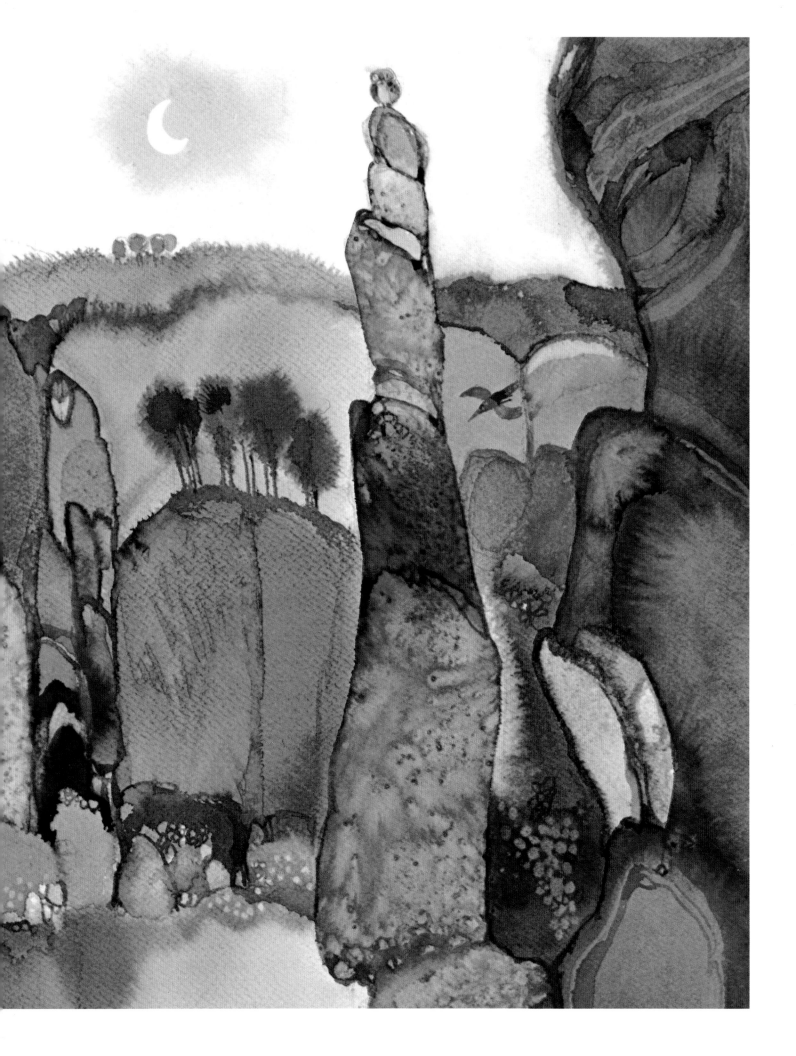

53 Lonesome / watercolour, 10 x 17cm

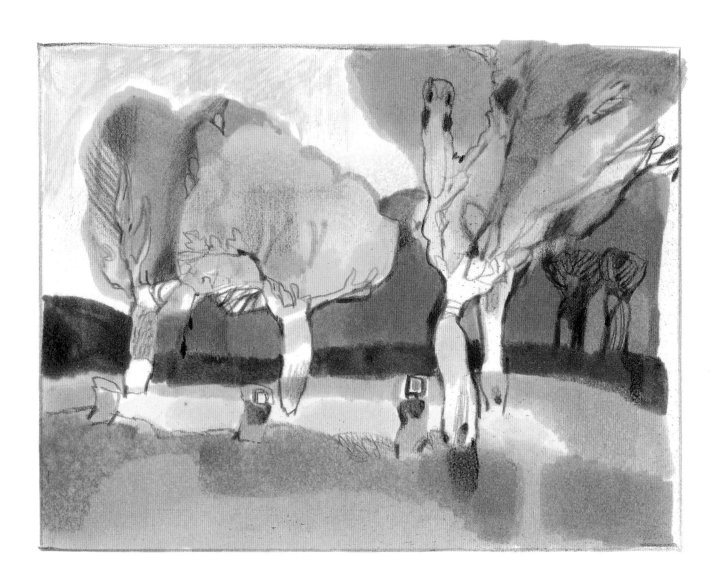

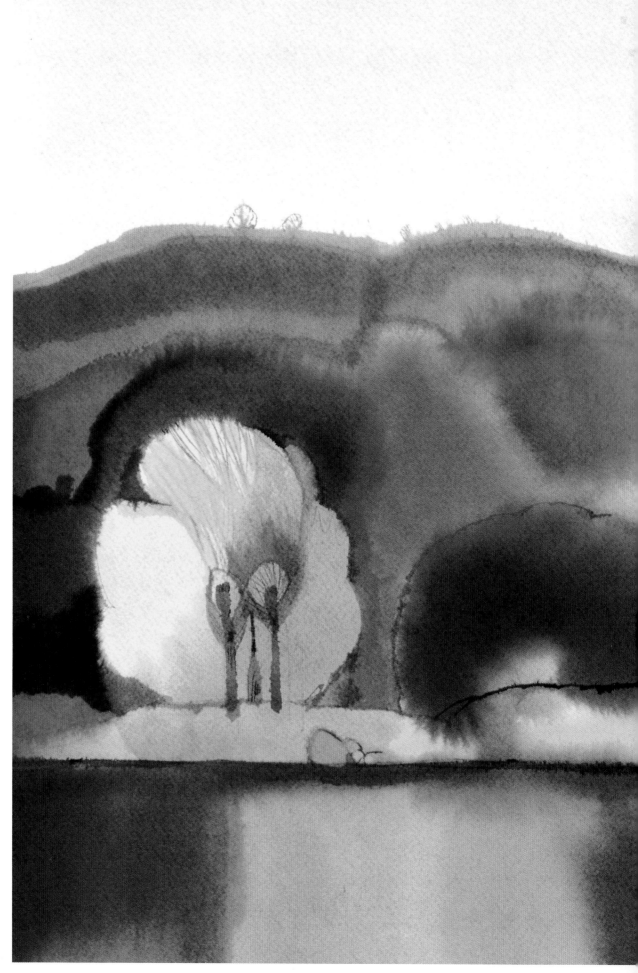

55 CANOEING / Book Illustration / watercolour, 26 x 43cm

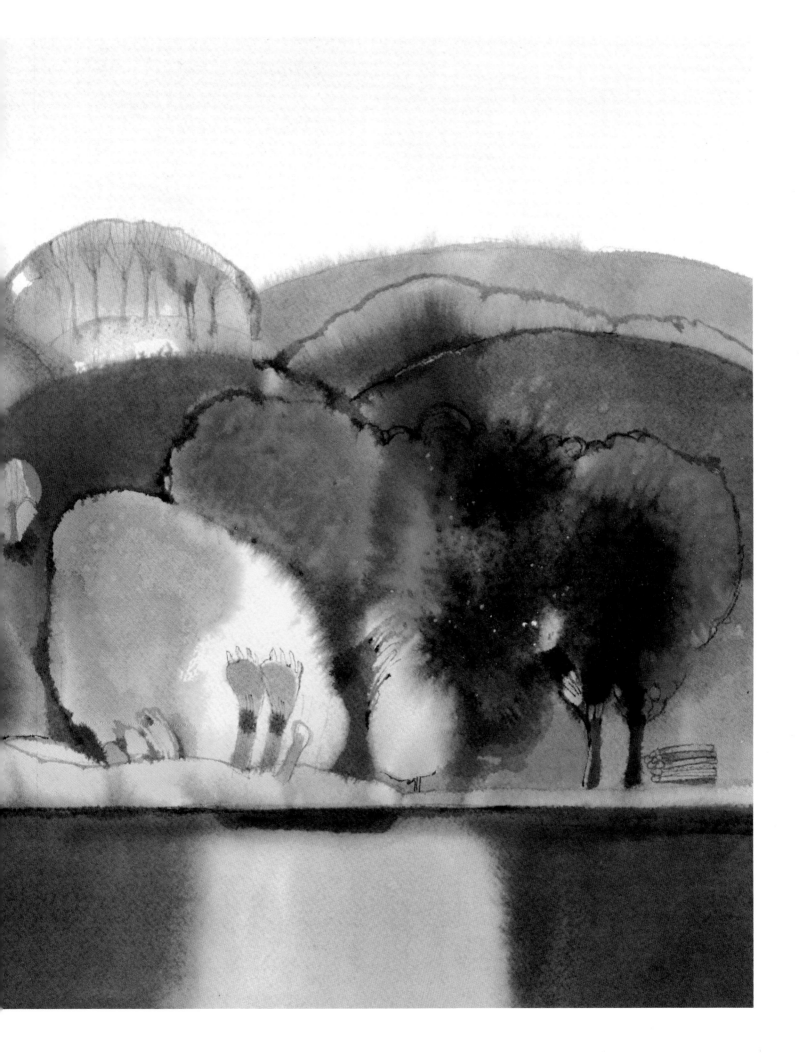

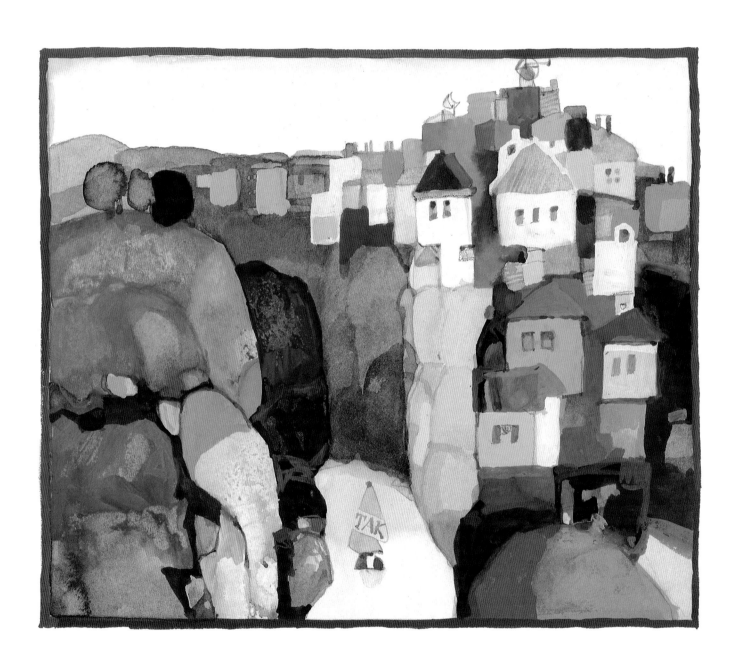

56 Town at the River / tempera, 15 x 18cm

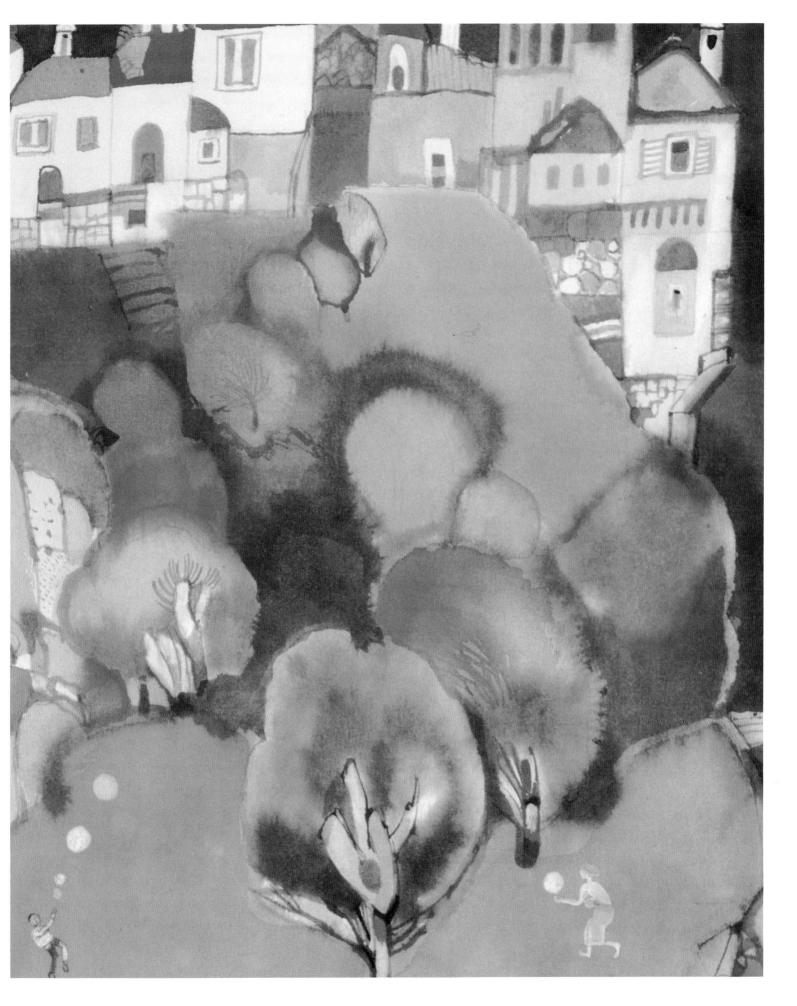

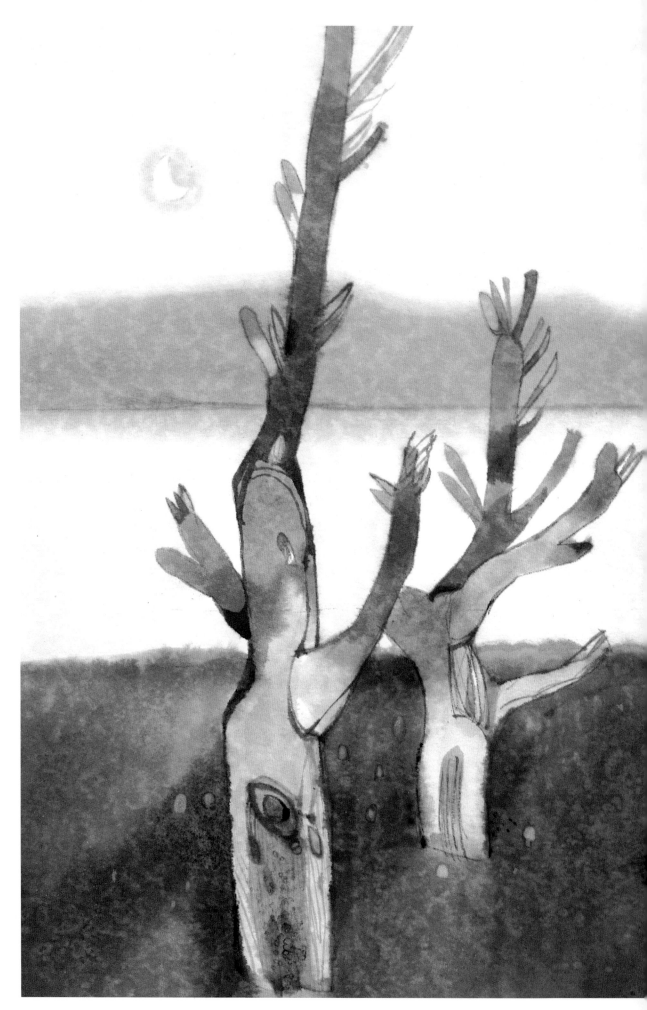

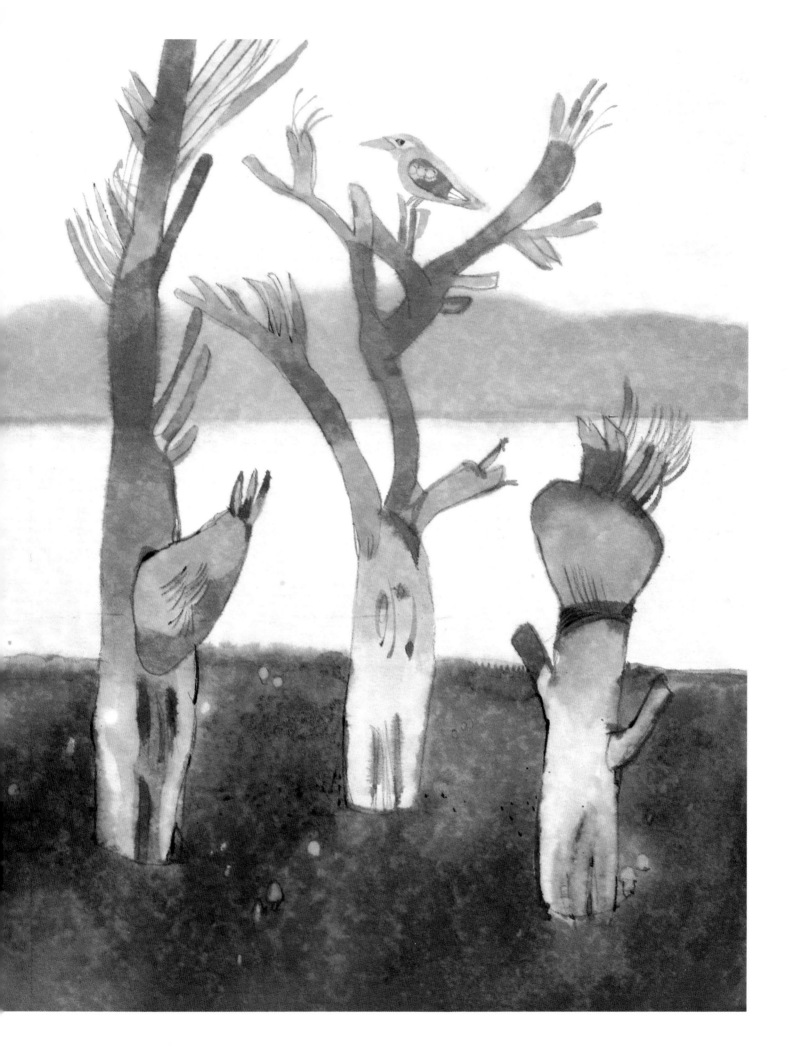

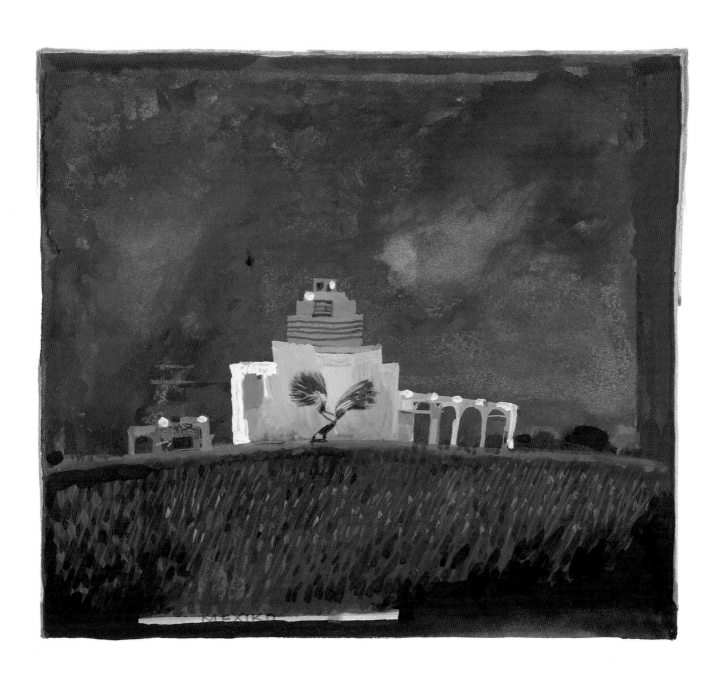

59 Mexico / tempera, 16 x 18cm

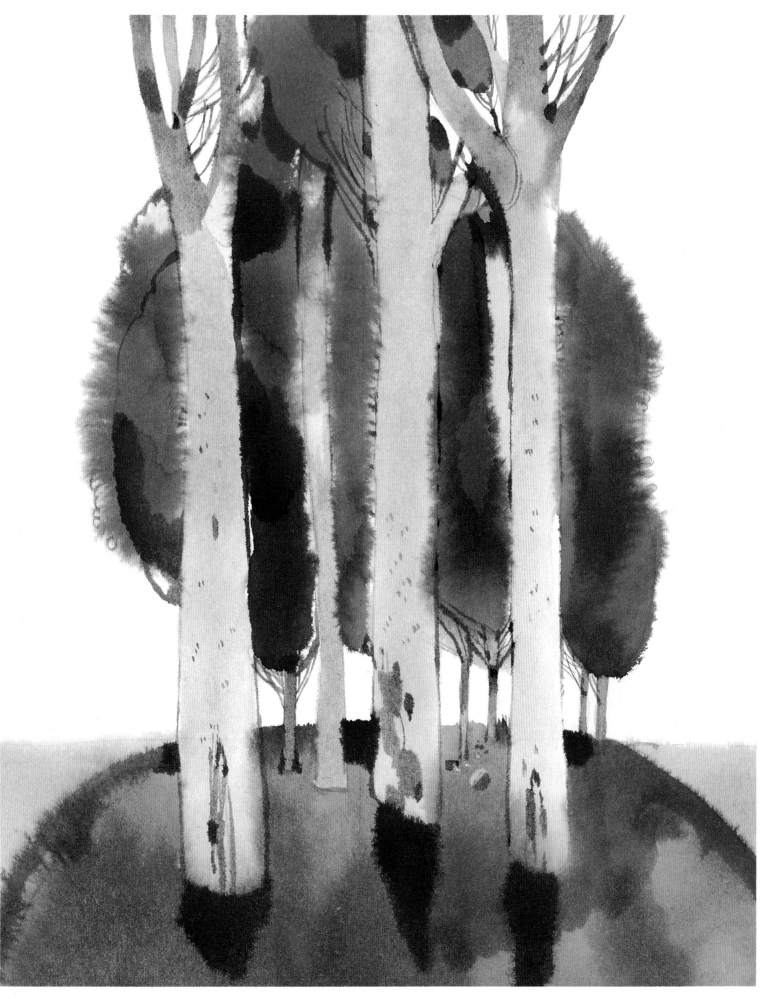

60 BROTHERS AND SISTERS / watercolour, 21 x 27cm

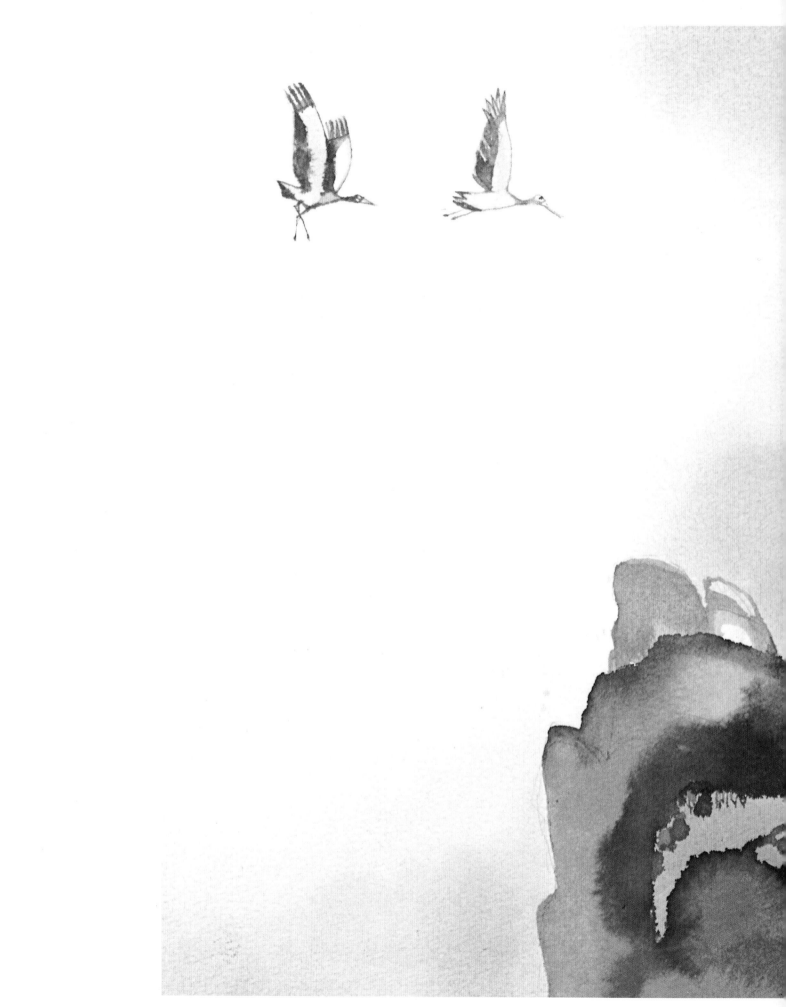

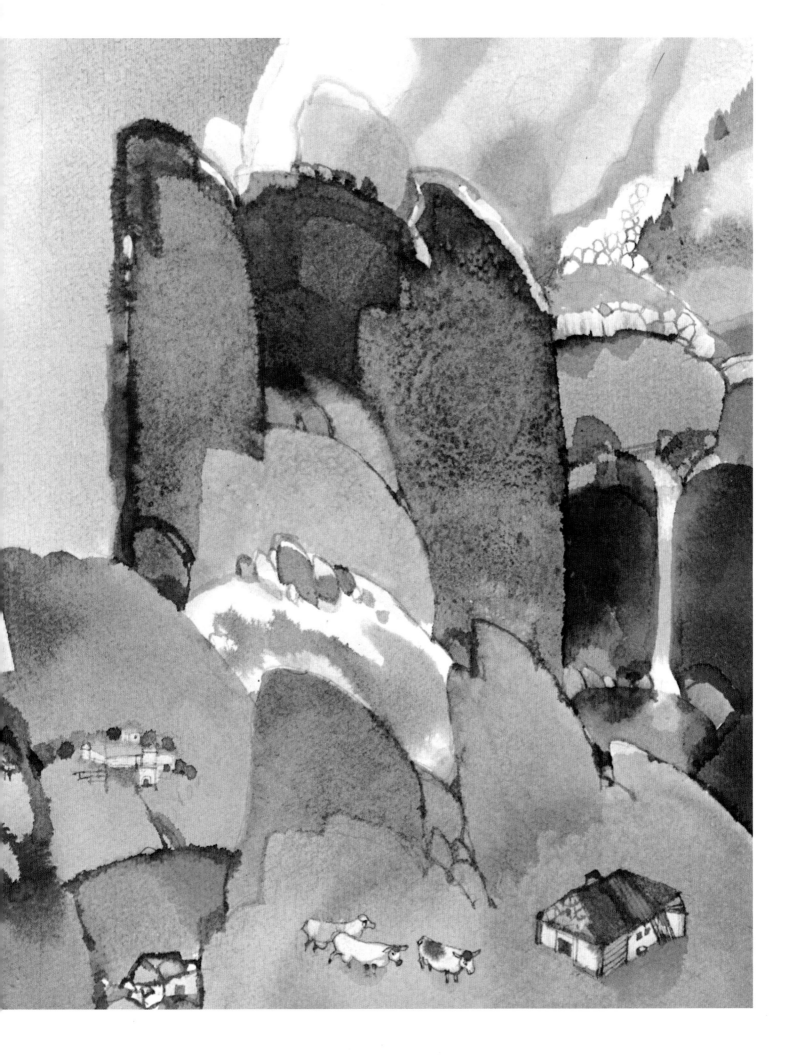

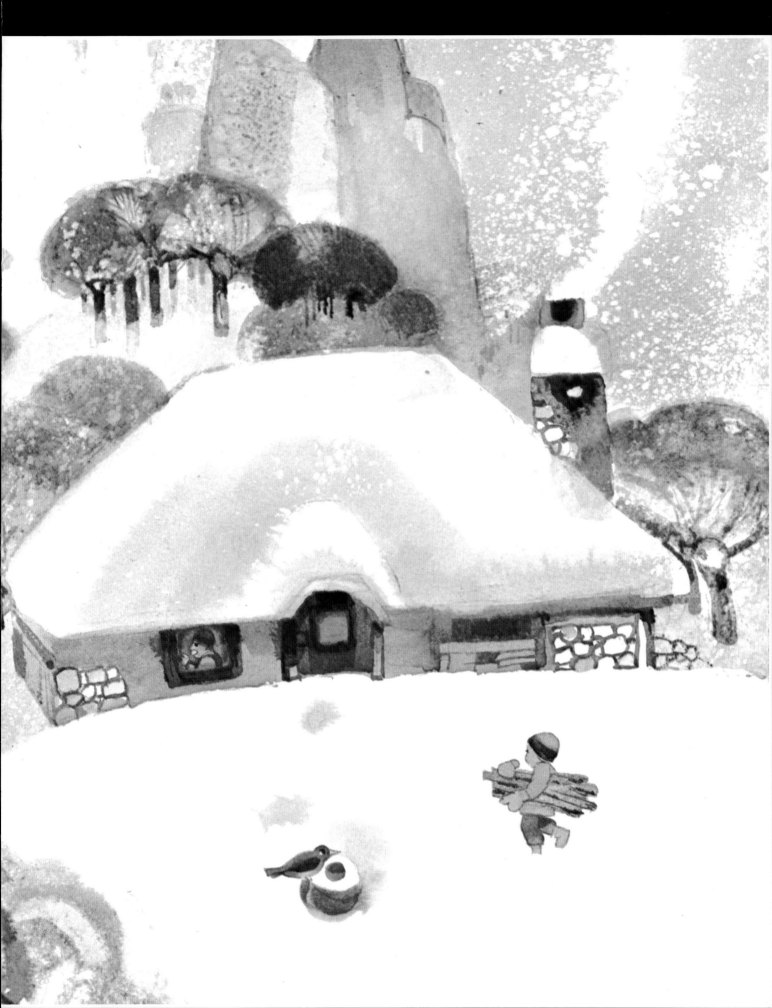

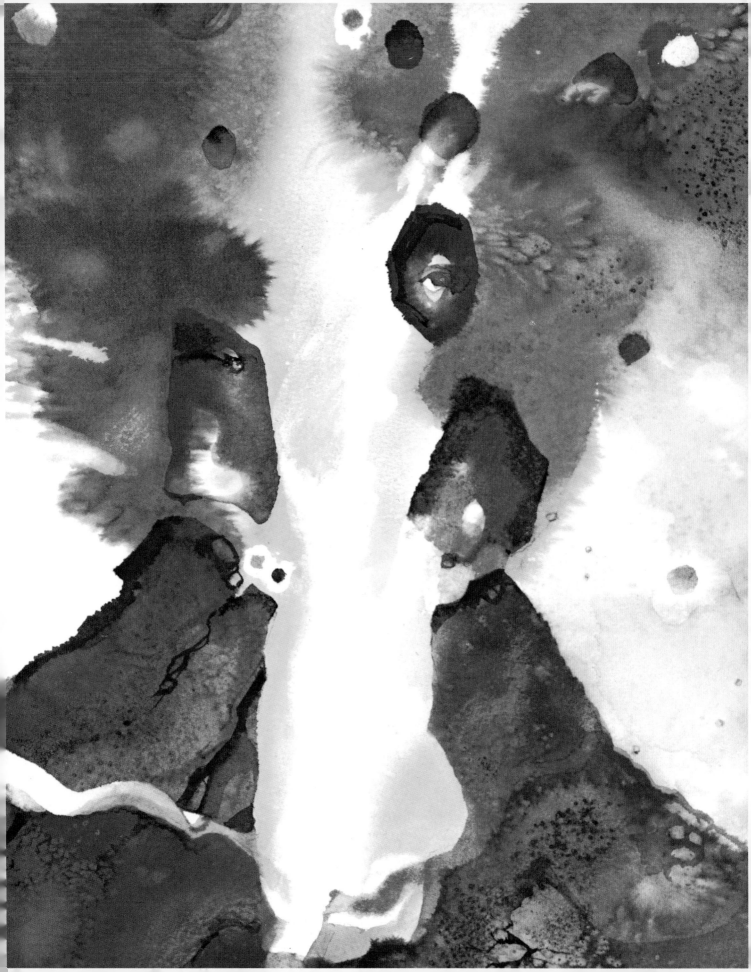

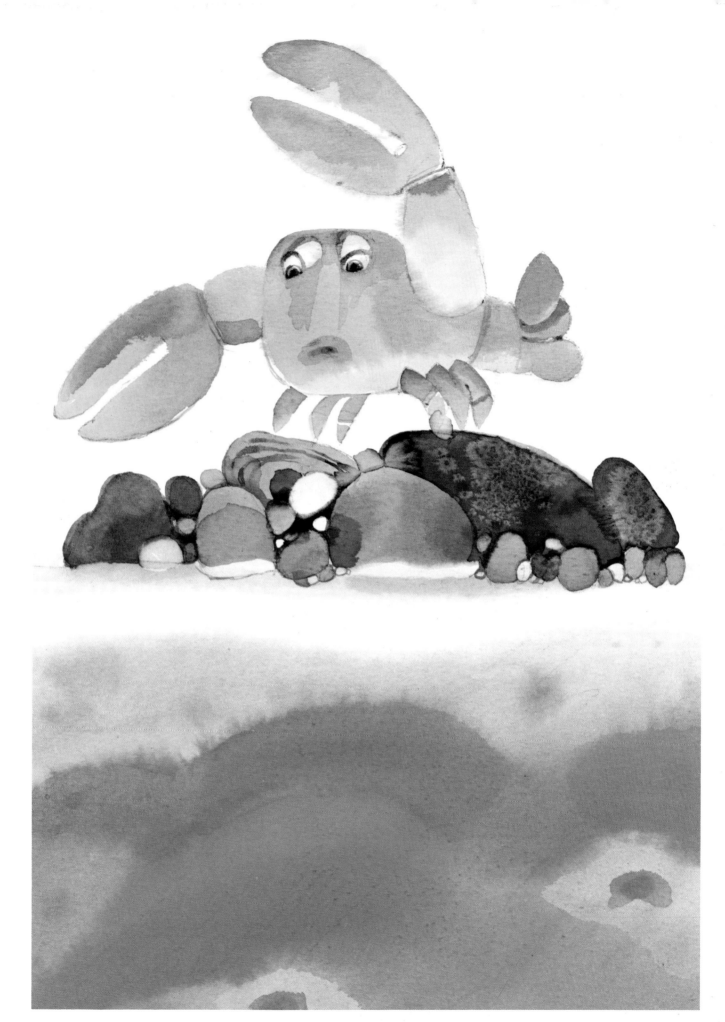

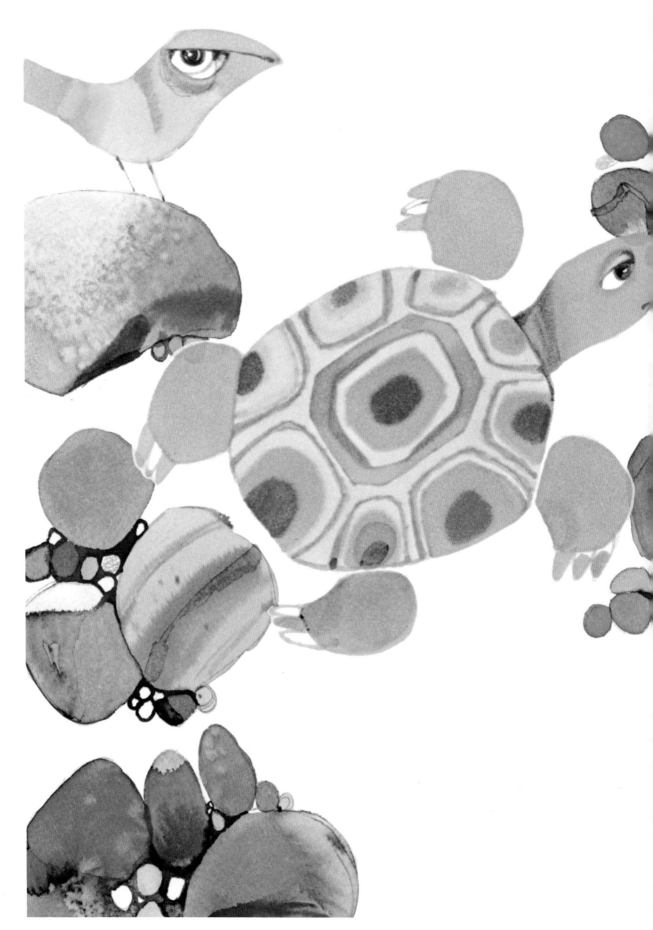

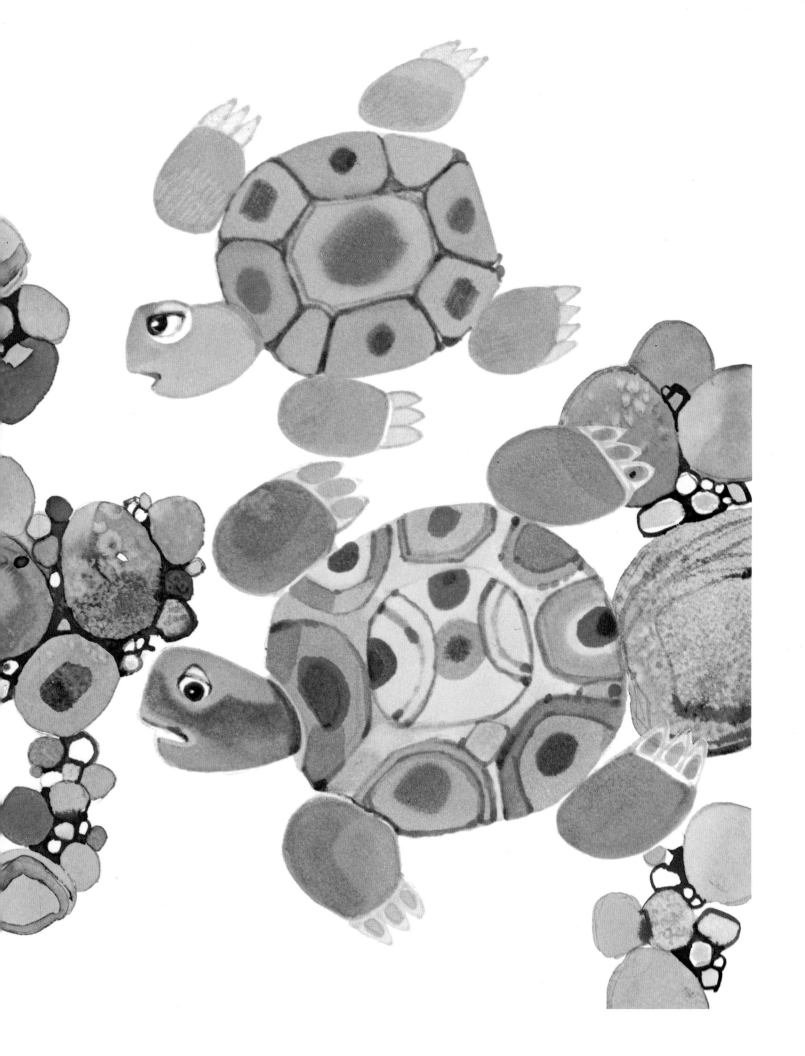

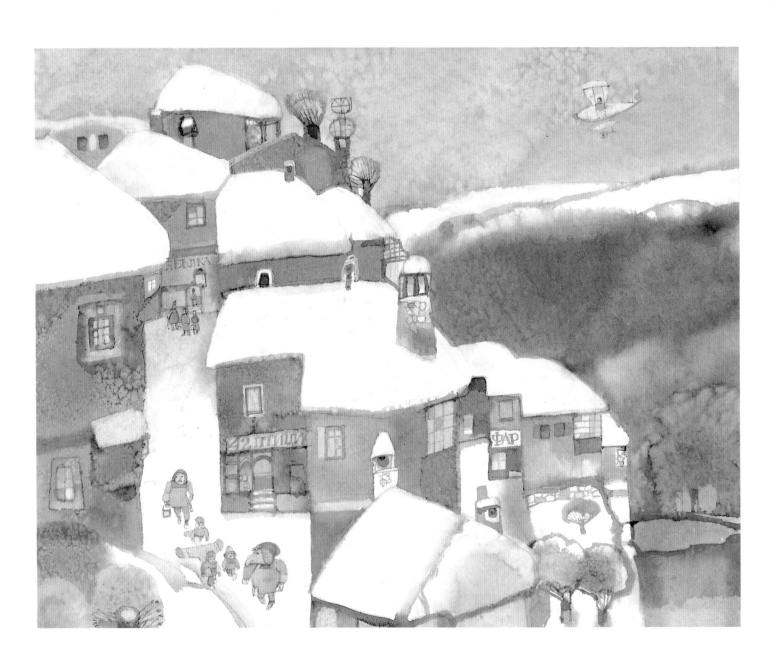

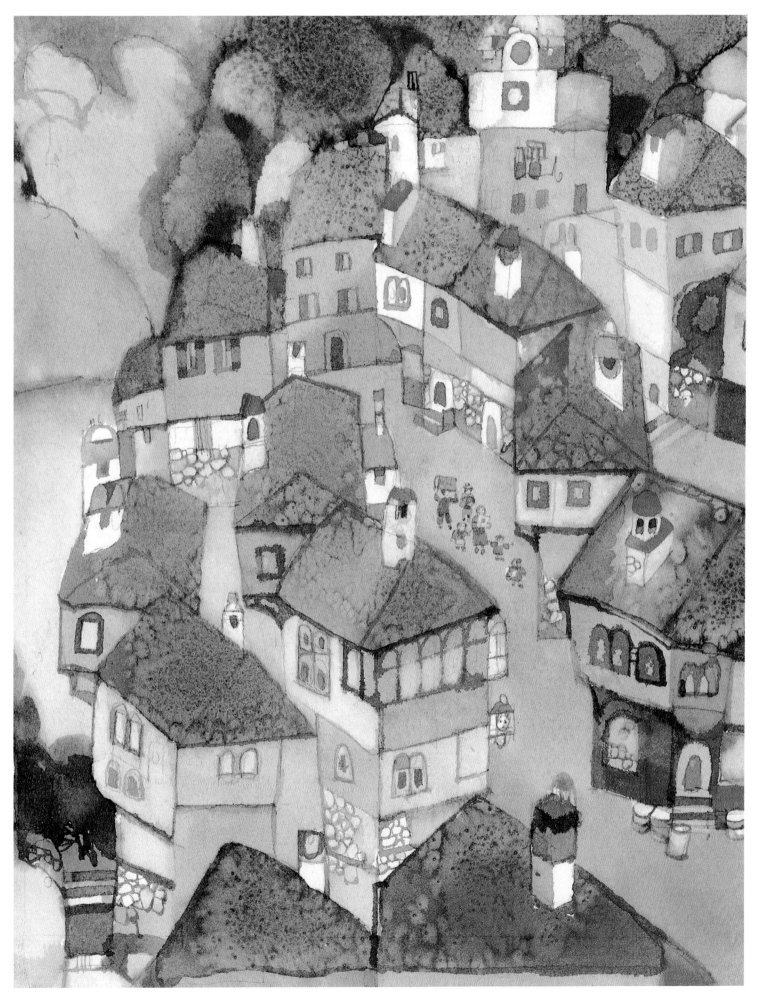

67 THE STRANGER / Book Illustration / watercolour, 33 x 45cm

I like animals very much, and I often paint them. I believe, once upon a time, animals were human beings who changed for the better. Most of all, I am fascinated by their ability to find their way in the realm of the senses. With the naiveté of a child, they sense everything without wanting to know, without the desire to write a scientific essay. I think an artist can learn much from animals. Snobs, rationalists, and purists undoubtedly disagree.

Ich male oft Tiere, da ich sie sehr gerne habe. Ich glaube, Tiere waren einmal Menschen, die besser geworden sind. Am meisten fasziniert mich ihre Fähigkeit, sich frei im Reich der Sinne zurechtzufinden. Mit der Naivität des Kindes fühlen sie alles, ohne wissen zu wollen, ohne das Bedürfnis, darüber ein wissenschaftliches Werk zu schreiben. Ich glaube, von den Tieren kann ein Künstler vieles lernen. Snobs, Rationalisten und Puristen ist davon abzuraten.

68 A Day in the Life of Big Bert / Book Illustration / watercolour, 35 x 36cm

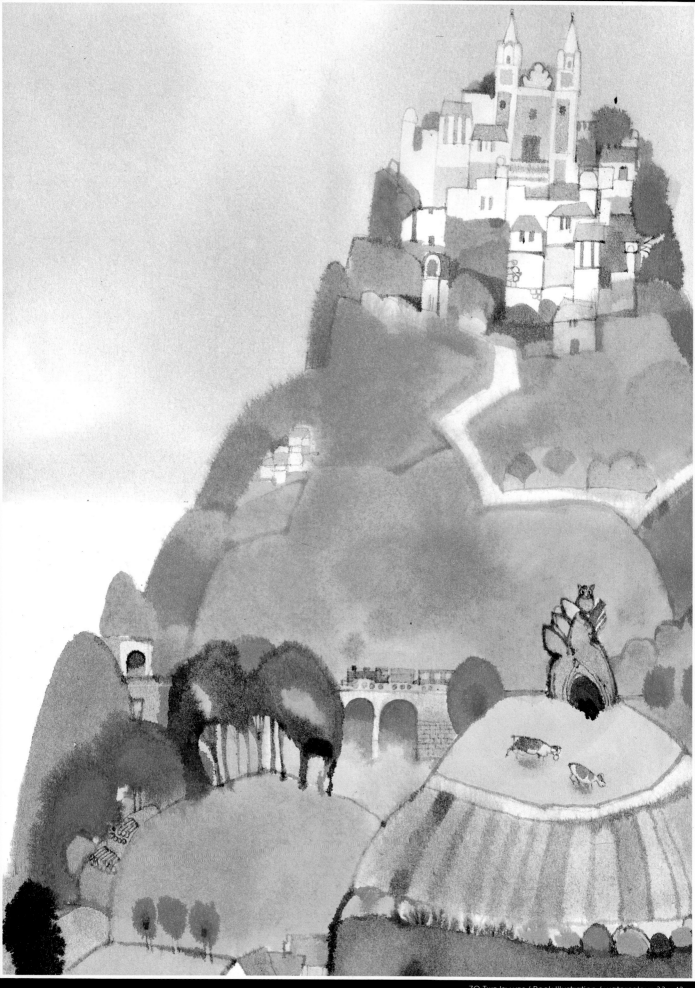

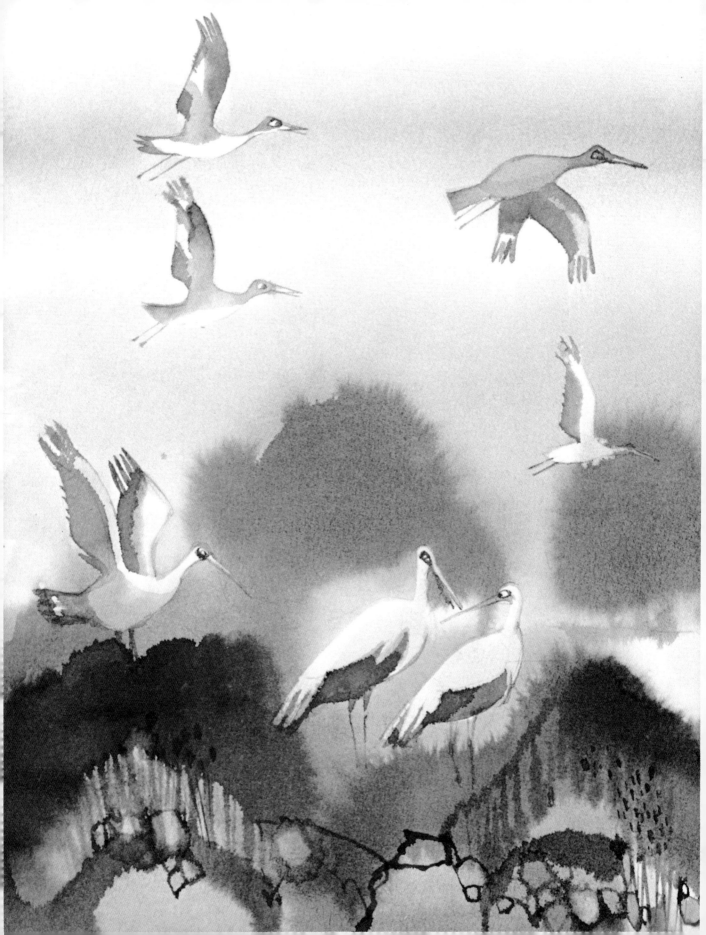

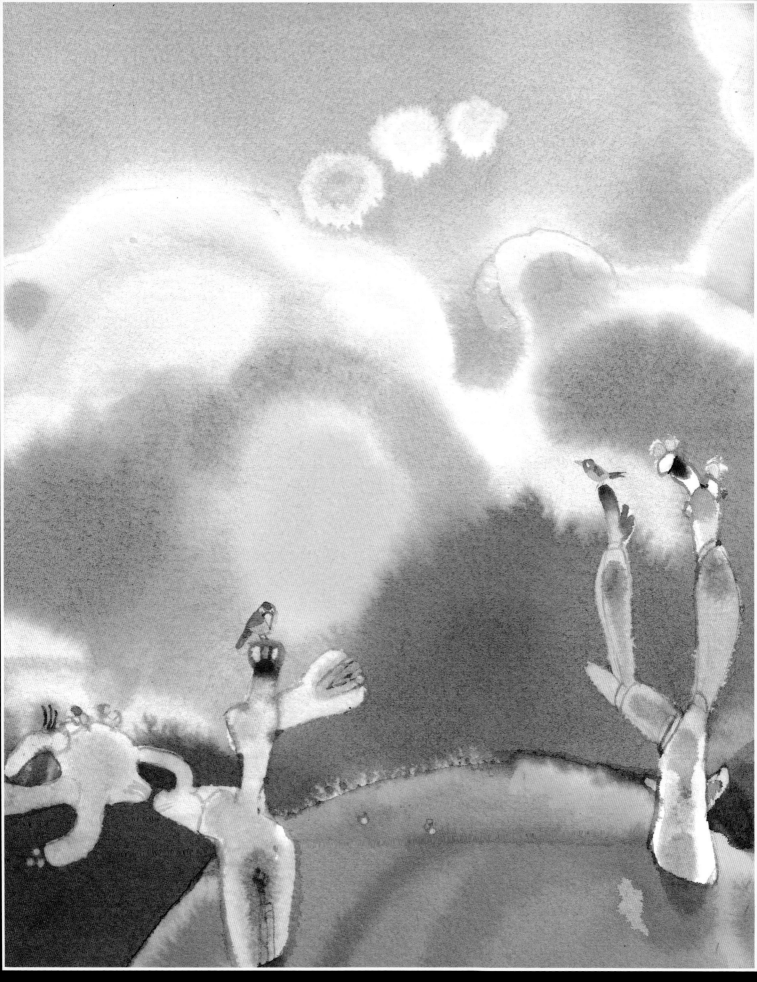

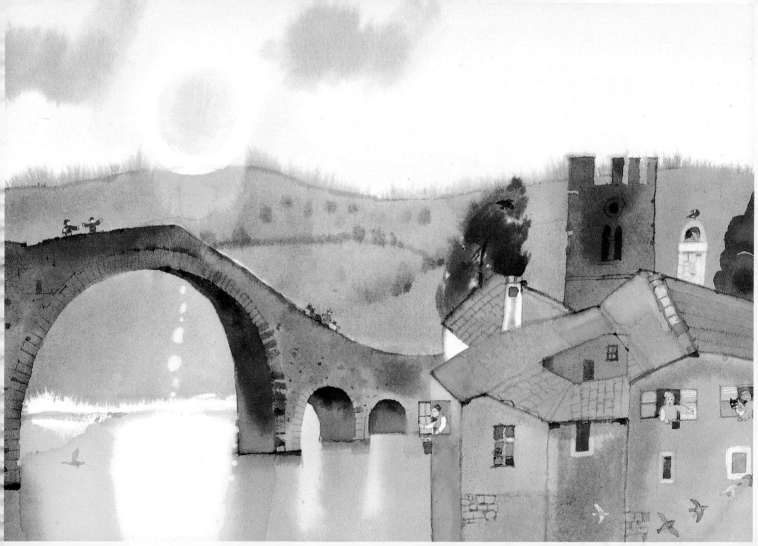

74 THE MOUNTAIN OF THE PHILOSOPHERS / watercolour, 8 x 6cm

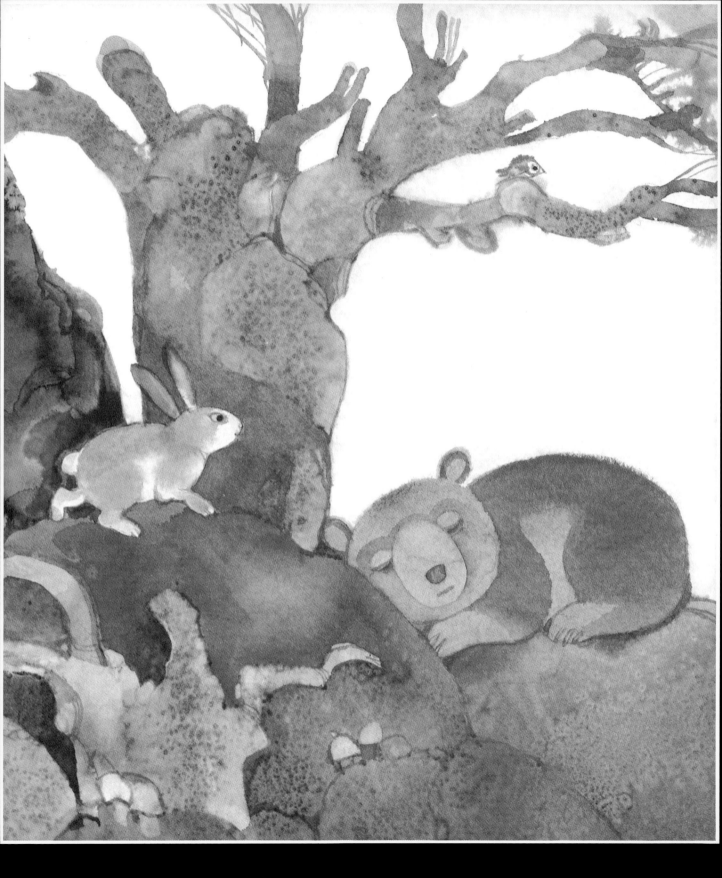

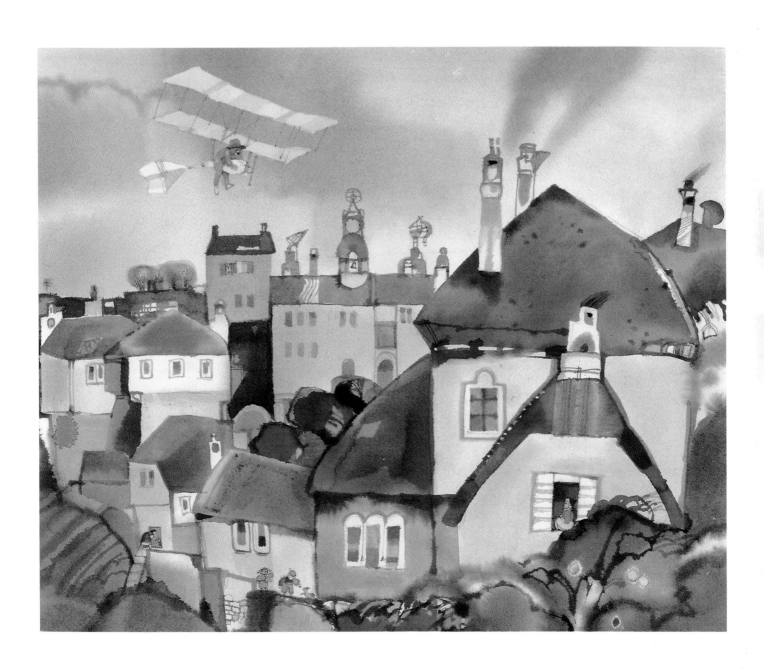

77 THE STRANGER/ Book Illustration / watercolour, 21 x 27cm

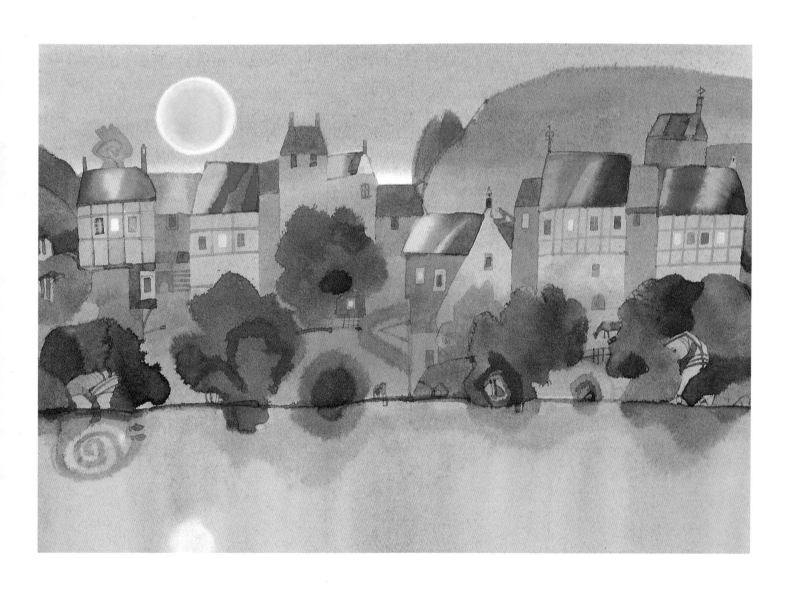

78 GOOD MORNING, GOOD NIGHT / Book Illustration / watercolour, 23 x 43cm

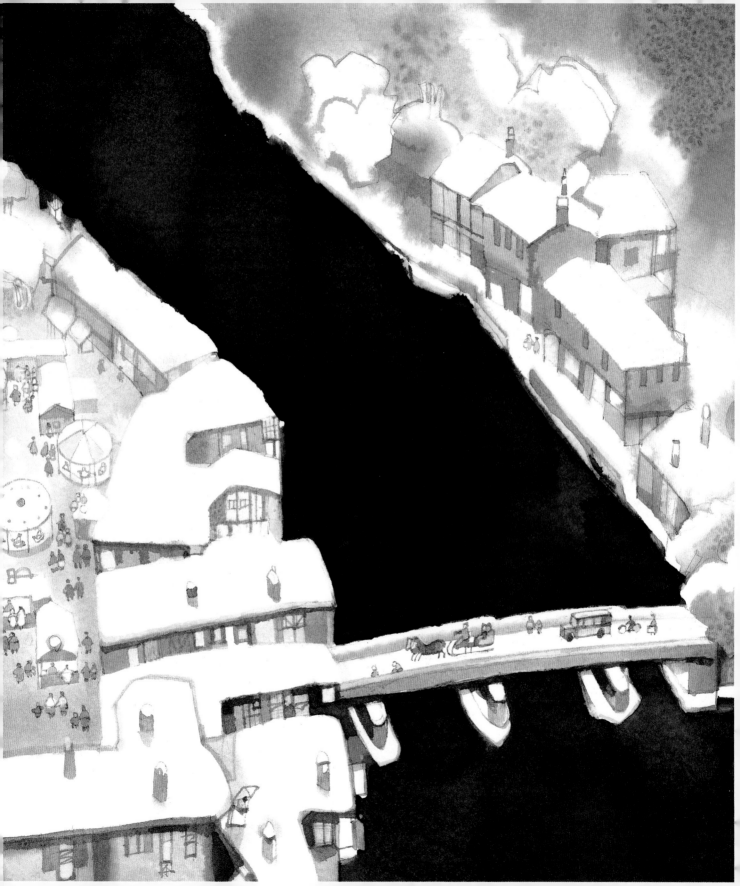

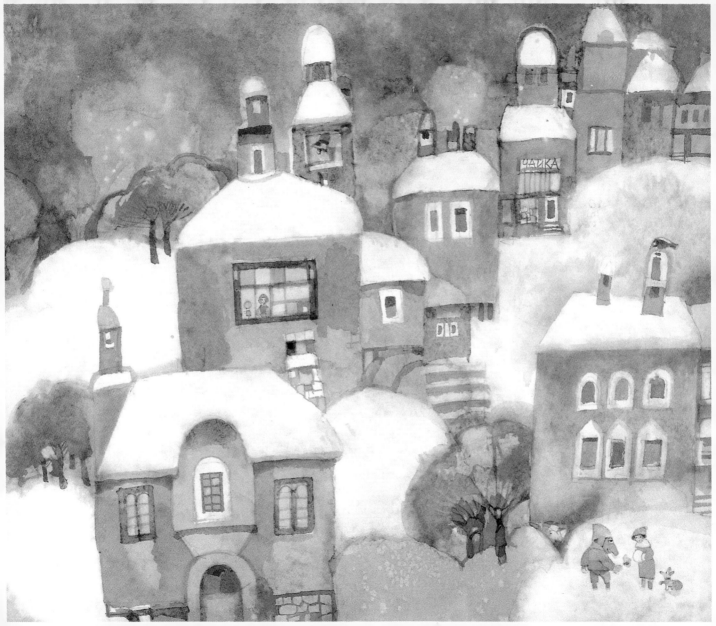

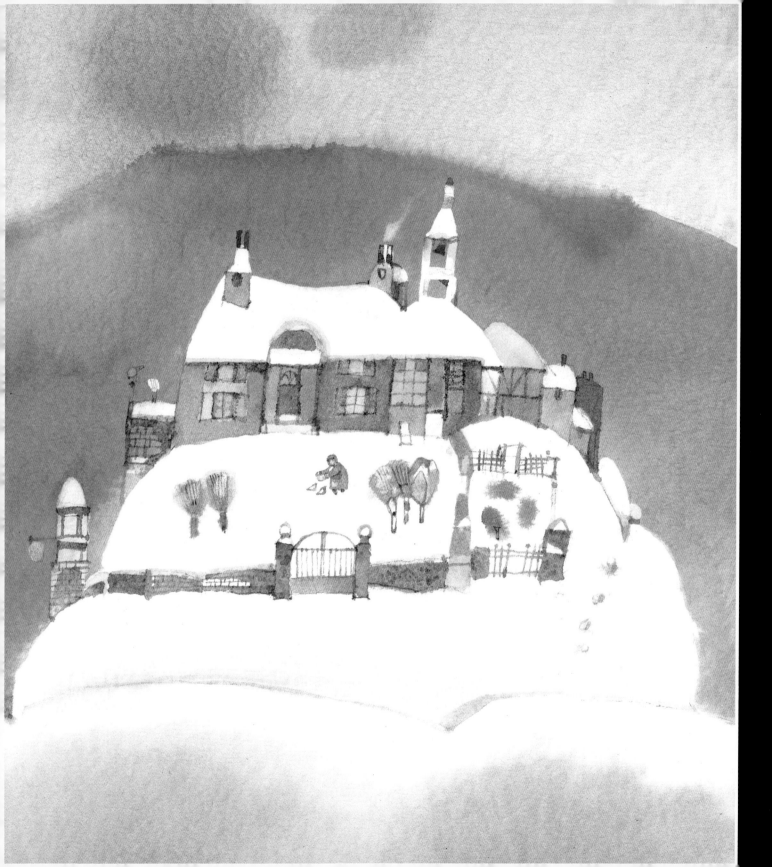

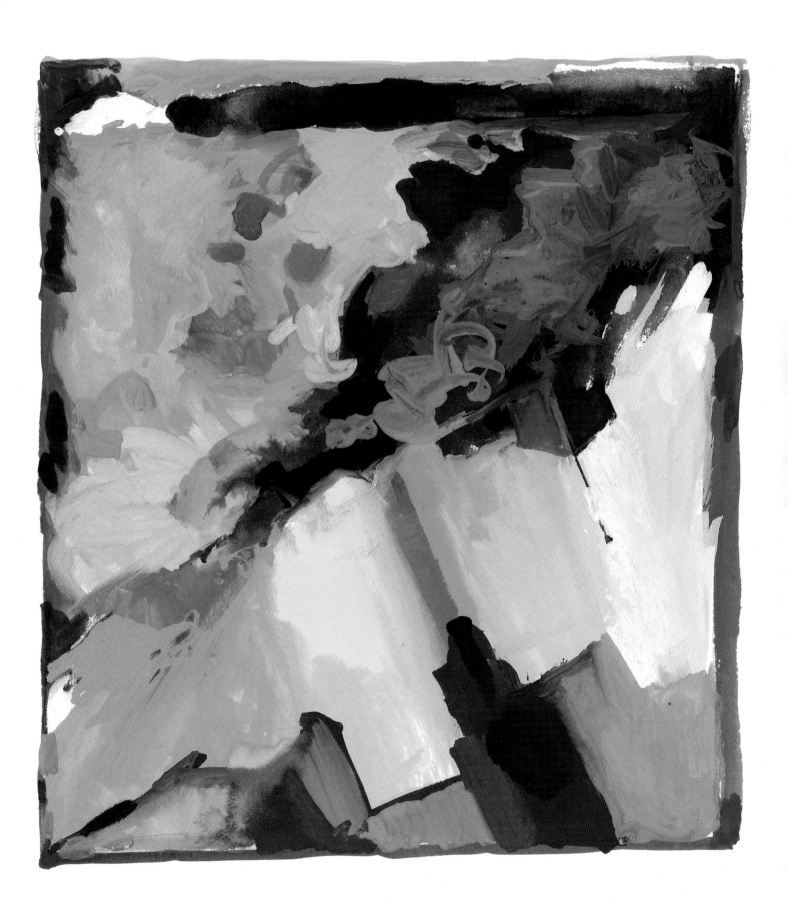

83 La Citta / tempera and watercolour, 28 x 24cm

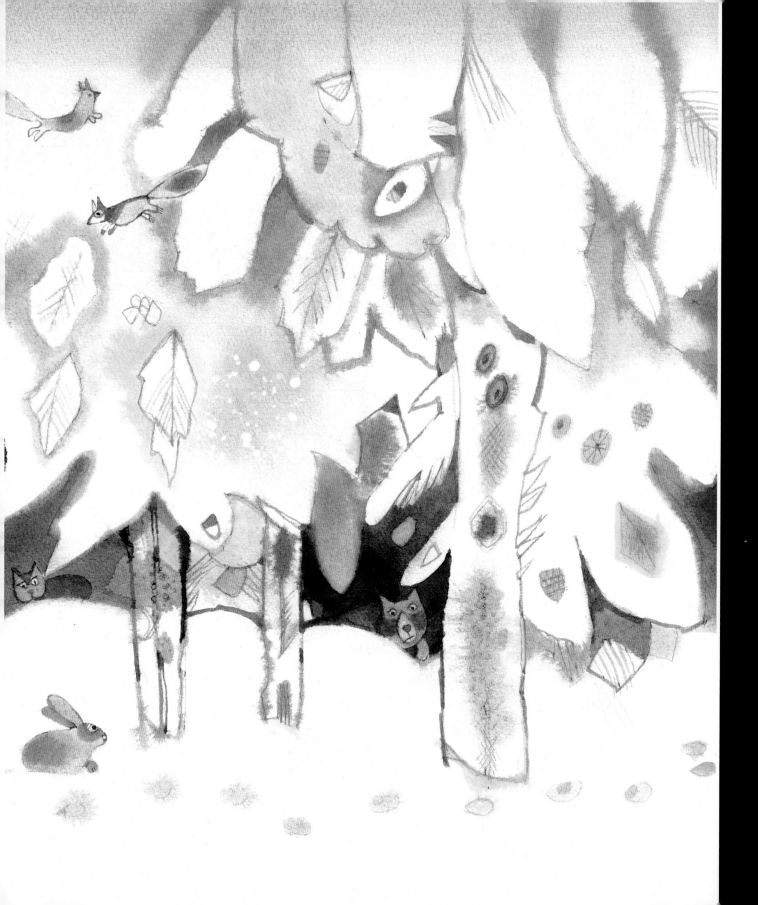

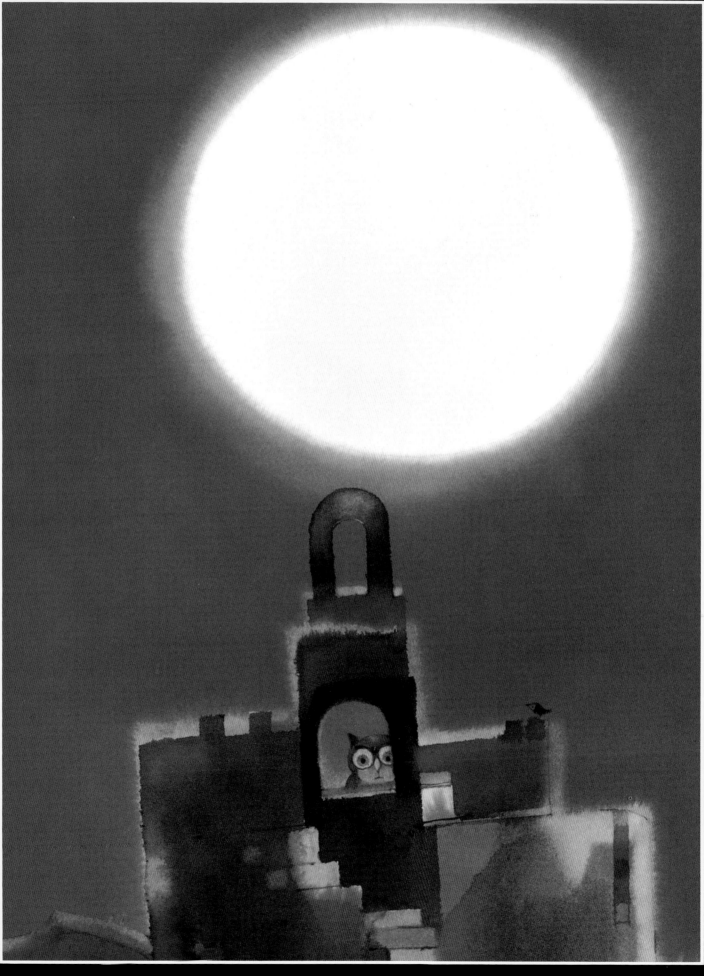

85 WO DAS GLÜCK WOHNT (WHERE THE LUCK IS) / Book Illustration / watercolour, 26 x 32cm

IVAN GANTSCHEV –
The Watercolourist
Barbara Scharioth

His first love is the water-colour, true water-colour painting with brush and water, that is – not mere water-coloured drawings. The technique of true water-colour permits "spontaneous painting", which takes its life from the "controlled chance".

Ivan Gantschev is the most successful water-colourist among picture book artists and tries in this way to describe his picture book technique. Of course, he does not view his painting technique as a theoretical problem. The water-colour simply belongs to him, has become a part of his life. When you look at the best picture books published in Germany over the past fifteen years, you come across time and again Ivan Gantschev's books, among them so successful titles such as *Ota The Bear* (1977, published in ten countries so far), *The Moonlake* (1981), *Santa's Favorite Story* (1982), or *The Journey Of The Storks* (1983). In 1985 he was awarded the prize of the International Jury of the BIB, the Biennial of Illustrators in Bratislava, the most famous illustrators' exhibition in the world.

Only a few German artists have received this award. From the titles alone you can recognize a second characteristic of Ivan Gantschev's picture books. Most of them – and in my opinion, the best of his picture books – are dedicated to nature. From his flat on the fourth floor in the West end of Frankfurt, where he can see a lot of the sky but only scarce patches of green, the painter has dreamt and imagined extensive landscapes with sleepy villages, dense woods, clear lakes, murmuring streams, and wonderful mountain vistas – often in the change of the seasons.

His feeling for nature is heightened by this wish for harmony, by his notion of the unity of plants and animals under an all-outstretching sky. He translates this visually into scenery that is expansive, but which conveys

IVAN GANTSCHEV – der Aquarellist
Barbara Scharioth

Seine Liebe gehört dem Aquarell. Nicht die kolorierte, oder genauer, die aquarellierte Zeichnung ist damit gemeint, vielmehr das Malen mit Pinsel und Wasserfarben. Die Technik des Aquarells erlaubt eine „spontane Malerei", eine, die vom „gelenkten Zufall" lebe. Ivan Gantschev, der erfolgreichste Aquarellmaler unter den Bilderbuchkünstlern – im eben definierten Sinn – versucht so, seine Bilderbuchtechnik zu beschreiben. Doch natürlich ist die Maltechnik für ihn kein theoretisches Problem. Das Aquarell gehört einfach zu ihm, ist Teil seines Lebens geworden. Wer die in der Bundesrepublik erschienenen Bilderbücher der letzten 15 Jahre an sich vorüberziehen läßt, stößt immer wieder auf Ivan Gantschevs Bücher, darunter so erfolgreiche wie „Ota, der Bär" (1977, bisher in zehn Ländern erschienen), „Der Mondsee" (1981), „Die Weihnachtsgeschichte" (1982) oder „Jakob, der Storch" (1983). Für dieses Buch wurde ihm 1985 von der internationalen Jury der BIB, der Biennale der Illustratoren in Bratislava, die alle zwei Jahre stattfindet und als die Illustratorenschau der Welt gilt, eine Plakette zuerkannt. Diese Auszeichnung konnten bisher nur wenige deutsche Künstler nach Hause holen.

An den genannten Titeln läßt sich ein zweites Charakteristikum der Bilderbücher Ivan Gantschevs ablesen. Viele, die allermeisten sogar – und in meinen Augen die besten – seiner Bilderbücher sind der Natur gewidmet. Der Maler, der vom Fenster seiner Wohnung im Frankfurter Westend aus nur noch spärliches, städtisches Grün sieht, der allerdings viel Himmel vor sich hat, weil im vierten Stock wohnend, dieser Maler erträumt sich seit je mit Pinsel und Farbe weite Landschaften mit verträumten Ortschaften, dichte Wälder, klare Seen, sprudelnde Flüsse und anheimelnde Bergwelten – oft im Wechsel der Jahreszeiten. Sein Naturverständnis ist geprägt von dem Wunsch nach Harmonie, von seiner Vorstellung der Einheit von Pflanzen und Tieren unter einem alles überspannenden Himmel, von einer Weite, die zugleich Nähe, weil Geborgenheit vermittelt.

Die Texte zu seinen Bilderbüchern sind zum Teil selbst erdacht und reflektieren das Thema Natur auf unterschiedliche Weise. Stets jedoch suchen sie ein gutes, versöhnliches Ende. Der sanfte Klang dieser Bilderbücher, ihre wärmende Ausstrahlung, ihre unspektakulären, einfachen Geschichten mit klaren Botschaften haben Gantschevs Bilderbüchern einen festen Platz in unseren Kinderzimmern erobert.

Das war keineswegs von Anfang an so. Zunächst wollte kein deutscher Verleger seine Bilder drucken, und so erschienen sie zuallererst in Japan. Einige der dort publizierten Bilderbücher gibt es bis heute nicht in deutschen Ausgaben. Begonnen hatte es mit „Mäusemax fliegt um die Welt" (1973) und „Die Geschichte vom Birnbaum" (1974, beide RSW, Esslingen), die durch ein Gespräch während der Buchmesse 1972 beim großen japanischen Verlag Gakken zustandekamen. Die Japaner waren damals sofort bereit, Gantschevs Bilder zu publizieren. Sie kauften die Rechte allerdings für ein „Spottgeld", gemessen an den in Japan erzielten Auflagen von 120.000 bis 130.000 Exemplaren, und ohne Umsatzbeteiligung.

Doch die gute Resonanz bei den Japanern machte Gantschev damals Mut, die Bilderbuchmalerei weiterzuführen. 1975 erschien in Japan „Siri und der Tiger", zu dem Gantschev selbst erstmals den Text schrieb. Ein Jahr später kam das Bilderbuch beim Peters Verlag in Hanau heraus. Von nun an gab es regelmäßig in verschiedenen Verlagen seine Bilderbücher, die meisten sind beim Neugebauer Verlag erschienen.

Wer sich allerdings heute, nachdem etwa 30 Bilderbücher von ihm in deutschen Ausgaben erschienen sind – und viele von ihnen zuerst in einem deutschen Verlag – über Gantschev und seine Bücher kundig machen will, muß ihn schon besuchen. Zurückhaltend, beinahe scheu, erzählt er von sich, nur ungern bereit, „Privates" vor anderen auszubreiten.

Dennoch einige Fakten. Geboren 1925 in Tirnovo, Bulgarien, absolviert er ein Studium der Malerei und Grafik an der Kunstakademie von Sofia. Durch politische Unruhen und die erste bulgarische

at the same time a sense of home and security.

Most of the texts of his books have been written by himself and reflect nature themes in different ways, but they always end with a happy resolution. The gentle tone of these picture books, the warmth they radiate, their unspectacular, simple stories with clear messages – these qualities have earned Gantschev's picture books a secure place in the playrooms and nurseries of our children.

But by no means has it been this way from the beginning.

At first, no German publisher wanted to print his picture books and that is why they were published first in Japan. Some of the books published there still do not exist in a German edition. It started with *Mousemax Flies Around The World* (1973) and *The Story Of The Pear Tree* (1974, both by RSW, Esslingen). These books resulted from conversations at the Frankfurt Book Fair in 1972 with the big Japanese publisher Gakken. At that time, the Japanese were eager to publish Gantschev's pictures. They bought the rights, but they paid only a ridiculously small flat fee. They printed and sold an edition of 120,000 to 130,000 copies, and Gantschev received no royalty on these sales.

But the excellent response of the Japanese encouraged Gantschev to continue painting picture books. In 1975, the book *Siri And The Tiger* was published in Japan, and for the first time Gantschev wrote the story himself. One year later, this picture book was published by Peters Verlag, Hanau, Germany. Since then about 30 of his picture books have been published first in the German language, most of them by Neugebauer Verlag, Salzburg.

But anyone who wants to know more about Gantschev and his picture books will have to visit him. Reserved, almost shy, he speaks from deep within himself, disclosing private thoughts and feelings with reluctance. Nevertheless, here are some facts.

He was born in 1925 in Tirnovo,

Bulgaria, and studied painting and graphics at the Academy of Art in Sofia. Due to the political riots and the first Bulgarian purge in 1949, he had to leave the Academy and was called up to the army. In the time after Stalin, more relaxed political circumstances gave him more possibilities for artistic work. He developed book covers, created drawings for public relations, designed posters for theatre plays and films, and took part in projects of the government's "art at the construction". But again and again he had to justify himself, because "under totalitarian regimes many feel bound to give signals".

Those years have left a mark, for even today, after living in Germany so long and being a German citizen for ten years, Gantschev speaks and expresses himself very cautiously.

Tired of the constant effort to keep the political surveillance at bay, he looked for an escape abroad. He met a German woman at the Black Sea coast, and after their marriage, he finally applied for a passport. He visited Germany in 1966, and never returned. His father, an innocent murder victim under the old regime in Bulgaria, was eventually "rehabilitated", but still Gantschev has not been back to his homeland. From then to now Ivan Gantschev has been living in Germany. He earned a living first working for a big newspaper, the RHEINPFALZ, designing posters, advertisements, and layouts. Later on he moved to Frankfurt and worked for a multi-national public relations agency until 1988. Since then he has been a free-lance artist.

For Ivan Gantschev, being an artist means being a picture book artist, because the picture book is his very own domain, with lands and peoples, scenes and settings, laws and justice under his own control. His pictures and stories have grown from the rich context of his own experiences and his own dreams of a better world. He finds great individual freedom within the somewhat narrow limits of a narrative structure.

Säuberungswelle 1949 bedingt, muß er die Akademie verlassen und wird zur Armee eingezogen. Eine größere Rehabilitierungsaktion in der Nach-Stalin-Zeit gibt ihm wieder mehr Möglichkeiten zu künstlerischer Arbeit. Er entwickelt Buchumschläge, zeichnet für Werbezwecke, entwirft Plakate für Theaterstücke und Filme und ist an Projekten der „Kunst am Bau" beteiligt. Allerdings: Immer wieder muß er sich rechtfertigen, denn „in totalitären Regimes fühlen sich viele verpflichtet, Signale zu geben". So vorsichtig drückt Gantschev sich heute, nach vielen Jahren in der Bundesrepublik und seit zehn Jahren deutscher Staatsbürger, noch aus. Des ständigen Erwehrens gegen politische Überwachung müde, sucht er einen Weg ins Ausland. Nach der Heirat mit seiner westdeutschen Frau, die er an der Schwarzmeerküste kennenlernt, stellt er schließlich einen Antrag auf einen Reisepaß. Von seinem Besuch in der Bundesrepublik kehrt er, obwohl sein Vater, der unschuldig umgebracht worden war, inzwischen rehabilitiert wurde, nicht zurück. Das ist im Winter 1966/67.

Seither lebt Ivan Gantschev in Deutschland. Den Lebensunterhalt bestreitet er mit seiner Arbeit für eine große Zeitung, die Rheinpfalz. Er entwirft Plakate, Anzeigen, Layouts. Später wechselt er nach Frankfurt zu einer großen Werbeagentur und arbeitet dort bis 1988. Seither lebt er als freier Künstler.

Für Gantschev bedeutet das vor allem: Bilderbuchkünstler zu sein, denn Bilderbücher sind seine ureigenste Domäne. Wenn er Bilder zeigt, entstammen sie meist einem bestimmten Kontext. Er teilt nicht ein in freie Arbeiten und Bilderbuchbilder. Für ihn liegt in der gebundenen Erzählform der je individuelle Freiraum. Auch in seinen Skizzenbüchern finden sich viele Zeichnungen und Aquarelle, aus denen später Bücher entstanden sind. Gantschev malt Geschichten, besser Abläufe von Geschichten, stets den Fortgang oder Wechsel im Blick, ein Vorher oder Nachher. Nicht das einzelne Bild ist für ihn die Herausforderung, sondern die Bilder in der Erzählfolge sind es. Vielleicht hängt es damit zusammen, daß er im Alltag in der Werbeagentur viele „storyboards" für Werbespots gemacht

hat, also Abläufe, skizziert für die spätere Umsetzung durch die Filmkamera. Auch wenn er beinahe abweisend über seine Tätigkeit in der Werbung spricht, wenn er sagt: „Werbung ist Strategie und keine Kunst", so scheinen geduldiges Arrangieren, Vereinfachen- und Weglassenkönnen, die Gantschevs Bilderbuchbilder prägen, nicht unbeeinflußt von der Arbeit an Werbekonzepten. Vor allem die unauffälligen Akzente, die erst beim zweiten Blick ins Auge springen, sprechen dafür. Ein Farbtupfer außerhalb der im Bild dominanten Farbskala, ein kleines Orange in einem vorwiegend grünblauen Kontext, ein scheinbar nebensächliches Rot in grauweißer Schneelandschaft werden kaum bemerkt und wirken doch entscheidend an der Stimmung, der Ausstrahlung der Bilder mit.

Mit diesen Beobachtungen bin ich wieder bei der Aquarelltechnik, die Gantschev verwendet, seit er als Kind zu malen begonnen hat. Zunächst einmal: Aquarellfarben sind Wasserfarben, die aus Pigmenten in einem wasserlöslichen Bindemittel bestehen. Sie leben in der Regel von ihrer Transparenz (es gibt allerdings auch deckende Aquarellfarben), lassen sie doch den Malgrund je nach Intensität des Farbauftrages mehr oder weniger stark durchscheinen. Seit je wurden sie zum Kolorieren von Strichzeichnungen benutzt.

Erst im England des ausgehenden 18. und beginnenden 19. Jahrhunderts wurde die Aquarelltechnik als eigenständige Malmethode entwickelt, man denke nur an William Turner oder John Constable. Im Bilderbuch ist die Technik der kolorierten Zeichnung sehr häufig zu finden. Von Lisbeth Zwerger bis Helme Heine, von F. K. Waechter bis Inge Steineke – sie alle nutzen mehr oder weniger ausgeprägt den Strich von Bleistift, Pinsel oder Feder als Begrenzung der Formen. Sie entwickeln häufig auch aus der Dualität von Farbauftrag und konturierter (schraffierter) Zeichnung und den Abweichungen voneinander eine je spezifische Eigenart. Ganz anders Gantschev. Auch er zeichnet den Bildaufbau, die Bildgegenstände vor und gibt den Landschaften Konturen. Doch sein Strich erscheint nicht sichtbar. Vorsichtig paust

Many drawings and water-colours in his sketchbooks have gone on to become the basis for books, for always Gantschev paints stories. It is the course of events, the development of a story, the before and after, that he loves. He is not challenged by the creation of a single picture, but rather finds his satisfaction in a sequence of pictures that tell a story.

Perhaps this approach was shaped by the many storyboards for commercials he did in the public relation agency where he also sketched the transposition for the film camera later on in the process. Although he speaks almost brusquely about his work in the PR agency when he says, "Advertising is strategy and not art" – still, his patient arranging, and the simplifying and leaving-out which characterize his picture book paintings, seem to be an influence resulting from his former job. This training as a visual communicator can be seen most clearly in the unobtrusive – yet purposeful – visual highlights which catch one's eye *consciously* only on careful examination of his work. One colour dot that clashes with the colours dominating a picture; a bit of orange in a predominantly green-blue context; a seemingly random touch of red in a grey-white snow landscape: all these are scarcely noticed but, nevertheless, have a definite impact on the atmosphere, the radiance of the pictures.

With these observations I have come back to the water-colour technique that Gantschev has been developing since he began painting as a child. First of all: water-colours consist of pigments in a water-soluble binding agent. Transparency is the essence of all but the purposefully opaque water-colours, and the painting ground shines through more or less, depending on how intensely the colour is applied. Since their earliest appearance, water-colours have been used to colour pencil drawings. Only in England at the end of the 18th and the beginning of the 19th century did the water-colour technique develop into an independent painting method – think of William

Turner or John Constable. In modern picture books you very often find this coloured-drawing style of water-colour. From Lisbeth Zwerger to Helme Heine, from F.K. Waechter to Inge Steineke, they all use more or less distinctly the stroke of the pencil, the brush or the pen, to define the boundaries of forms. These artists also develop some of the characteristics of their specific styles from the dual nature of applied water-colours and outlined or hatched drawings, benefitting from the differences between these combined media. Gantschev works completely differently. He also draws the configuration of the picture as well as its subjects and the outlines of the landscapes, but his line stroke seems to be invisible. Carefully, he traces the lines to the painting ground, so that they remain shadowy and soft. When applying the colour, he tries to confine the colour areas with different degrees of moisture. On dry paper there are "hard" boundaries between colours, while on wetter paper the colours blend more.

These techniques are Gantschev's specialty. They show his secure feeling for colours, his knowledge of the reactions of the different pigments. By dabbing, wiping, rubbing, and fast drying (with a hair-dryer) he influences the effect of the colours. With ox-bile, an organic substance, he takes the colour pigments off the paper and achieves in that manner speckles or patterns within the colour areas. As early as 1977 he had already mastered this diversified technique, as can be seen in Ota, der Bär (Ota The Bear, 1977). His absolute command of it is shown distinctly in the big double page pictures of his book Wo ich geboren bin (Where I Was Born, 1978) with poems by Silvius. It is not a picture book for children, but is rather a bibliophile book that will inspire adults to reflect upon and dream about the beautiful, atmospheric impressions of nature.

Gantschev's composition, his conception of the picture area, catches one's eye. It is simply area, nothing else. It

er Linien auf den Malgrund durch, damit sie schemenhaft weich bleiben. Beim Farbauftrag sucht er durch unterschiedliche Feuchtigkeitsgrade die Farbflächen zu begrenzen. Auf trockenem Papier läßt sich ein „harter" Farbrand erzielen, je nasser der Malgrund, um so mehr verläuft die Farbe.

Diese Farbverläufe sind Gantschevs besondere Spezialität. Sie zeigen sein sicheres Farbempfinden, seine Kennerschaft der Reaktionen verschiedener Pigmente untereinander. Durch Abtupfen, Wischen, Reiben, durch rasches Trocknen (mit dem Fön) beeinflußt er die Wirkung der Farben. Mit Ochsengalle, einer organischen Substanz, zieht er gar die Farbpigmente, wieder vom Papier und erreicht dadurch zum Beispiel Sprenkel oder eine Insichmusterung der Farbflächen.

Diese vielfältige Technik hat er schon in „Ota, der Bär" (1977) zur Meisterschaft gebracht. Ihre souveräne Handhabung zeigt sich besonders deutlich in den großformatigen Doppelseitenbildern von „Wo ich geboren bin", ein Jahr später erschienen, zu lyrischen Texten von Silvius. Dies ist kein Bilderbuch für Kinder, vielmehr ein bibliophiles Buch für Erwachsene, die von den atmosphärisch schönen, harmonischen Naturstimmungen zur eigenen Reflektion oder zum Träumen angeregt werden.

In diesen Bildern springt auch Gantschevs Auffassung der Bildfläche ins Auge. Sie ist reine Fläche, will nichts anderes sein. Sie ist zweidimensional, begrenzt vom Bildformat, dennoch häufig die Bildränder überspielend. Selten nur ist im Bildaufbau Tiefe angelegt. Landschaften, Bäume und Berge, Häuser, Plätze und Menschen bauen sich entweder auf schmaler Bildbühne, meist jedoch übereinander auf. Seine Ansichten von Dörfern und Städtchen sind „Häuserberge", bestehend aus sich übereinandertürmenden Flächen. Eindrucksvoll aus vielerlei Sicht ist das Bild des nächtlichen Bethlehem in „Die Weihnachtsgeschichte, erzählt vom Weihnachtsmann" (1982). Dieses Bild erinnert ein wenig an einige der vielen Tunis-Aquarelle von August Macke, die dieser 1914 während zweier Wochen schuf. Mackes „Kairouan I" in der Münchner Staatsgalerie für Moderne

Kunst zeigt einen flächigen Aufbau, wohldosierte Naß-in-Naß-Technik in eindrucksvollem Wechselspiel mit trockenen, harten Rändern und begrenzten Farbflächen. Macke indes versuchte, in diesen Aquarellen die Fläche aufzubrechen, Gegenständliches in seiner eindeutigen Form im Bilde aufzulösen, ohne die Tektonik der Komposition zu gefährden. Ivan Gantschev sucht einen anderen Weg. Ausgehend vom Bildformat, arbeitet er mit Balance und Ausgewogenheit der Bildelemente. Selbst in Bildern, die tiefenräumliche Vorstellungen implizieren, etwa in „Der Weihnachtszug" (1982), wird die Bildfläche nicht optisch aufgelöst. Dennoch findet Gantschev in der Bilderfolge zu einer ganz eigenen Dynamik. Sein Mittel der Spannung und Bewegung ist der häufige Wechsel des Augenpunkts der Bilder, mit dem er dem Betrachter das Gefühl eines ständig sich verändernden Standpunktes gibt. In „Jakob, der Storch" (1983) hat man den Eindruck, wie Nils Holgersson auf dem Rücken eines Vogels über Landschaften und Städte, über Flüsse und Meere zu fliegen. In „Der Mondsee" (1981) ist der Betrachter einmal nah, einmal fern – Regie par excellence! Im „Weihnachtszug" (1982), einer Geschichte, die in Gantschevs Familiengeschichte zurückreicht, und die er deshalb seiner Mutter gewidmet hat, schaut man zunächst von weitem, dann immer mehr mit den Augen des Kindes, das den heranbrausenden Zug vor einem auf die Geleise gestürzten Felsbrocken warnen will. Schließlich ist der Betrachter wieder draußen aus der Geschichte und nimmt im letzten Bild Abschied von einem einsamen Bahnwärterhäuschen in der verschneiten Bergwelt.

Wie sehr der Maler Aquarellist ist, zeigt sich an seinem Umgang mit Acrylfarben. In „Wo steckt Waldemar?" (1989), einer von ihm selbst getexteten Geschichte um einen unternehmungslustigen Maulwurf, arbeitet Gantschev mit deckenden Acrylfarben, als seien es Aquarellpigmente. Um Acrylfarbe zum Leben zu bringen, so Gantschev, brauche es viele Übermalungen, viele Lasuren übereinander. Die Malerei mit Acryl müsse „geführt werden", während es beim Aquarell sei wie bei einem Pferdewagen auf dem

is two-dimensional, limited by the picture format, yet often going across the bounds of the pictures. There is seldom depth in his pictures. Landscapes, trees and mountains, houses, squares, and people are arranged either on a small "stage" or more often one above the other. His views of villages and towns are "mountains of houses" consisting of piled-up areas. Especially impressive is his view of the nocturnal Bethlehem in the book *The Christmas Story by Father Christmas,* also published as *Santa's Favorite Story* (1982). This picture can be compared to one of the water-colours of Tunis by August Macke, painted during two weeks in 1914.

Macke's "Kairouan 1" in the State Gallery of Modern Art in Munich shows his arrangement of the areas, the purposeful wet-in-wet technique in an impressive interplay with dry, hard bounds and limited colour areas. Macke tried to break up the areas in these water-colours, to dissolve the objects in the picture in their clear form without endangering the tectonics of the composition. Gantschev applies a different method. Starting with the format of the picture, he works with the balance of the picture's elements. Even in pictures implying a profound spaciousness such as in *Der Weihnachtszug* (*The Christmas Train,* 1982), the area of the picture is not broken up optically.

But still, Gantschev finds a characteristic dynamic for the sequencing of his pictures. His means of tension and motion is the frequent change in the point of view. In *The Journey Of the Storks* (1983) one gets the impression of flying over landscapes and towns, rivers and seas, like Nils Holgersson on the back of a bird. In *The Moonlake* (1981) the onlooker is near one moment, then far away. In *Der Weihnachtszug* (*The Christmas Train,* 1982) – a story which goes back to Gantschev's family history and is therefore dedicated to his mother – you watch first from a distance, and then more and more through the eyes of the child who wants to warn the train that thunders

ever nearer of the rock that has fallen onto the rails. Finally, the viewer is again outside of the story, and in the last picture he bids farewell to the lonely linesman's house in the snow-covered mountain scenery.

The degree to which Gantschev is a water-colourist shows in his usage of acrylic colours. In *Where Is Mr. Mole?* (1989), a story he wrote about a venturesome mole, Gantschev works with opaque acrylic colours as if they were pigments of water-colours. To bring acrylic colours to life – according to Gantschev – requires many over-paintings, many layered glazes. A painting done with acrylic colours has to be "conducted", whereas a water-colour is like a horse-cart on its way home: if the coachman falls asleep, the horses find their way alone. The luminosity of these acrylic pictures is impressive. However, the brightness of a beach motif, painted a little later with water-colours, or the silvery shine of the nocturnal lake scenery in *Good Morning, Good Night* (1991) – a picture book about the rivalry and friendship between the sun and the moon – is unique. This quiet book, with very little action and a spare text written by Gantschev, shows perfectly his mastery of water-colours. It seems as if he paints his pictures with effortless ease. His recently published book, *The Christmas Teddy Bear,* gives the same feeling. Often, one gets the impression that in his water-colours and the accompanying stories, the painter is looking for the harmony he has lost in reality.

Heimweg. Schläft der Kutscher ein, finden die Pferde auch allein ihren Weg.

Die Leuchtkraft dieser Acrylbilder ist beeindruckend, doch der helle Glanz des wenig später in Aquarelltechnik gemalten Strandbildes oder das silbrige Strahlen der nächtlichen Seelandschaft in „*Guten Morgen – Gute Nacht*" (1991), einem Bilderbuch über Rivalität und Freundschaft von Sonne und Mond, ist einmalig. Dieses stille, handlungsarme Buch mit einem knappen Text des Malers zeigt besonders exemplarisch die große Könnerschaft des Aquarellisten, der seine Bilder mit einer Leichtigkeit zu malen scheint, wie sie oftmals auch von den Geschichten, zum Beispiel dem gerade erschienenen „*Weihnachtsteddybär",* ausgeht.

Es entsteht oftmals der Eindruck, als suche der Maler in seinen Aquarellen und den sie begleitenden Geschichten eine Harmonie, die ihm in der Wirklichkeit abhandengekommen ist.

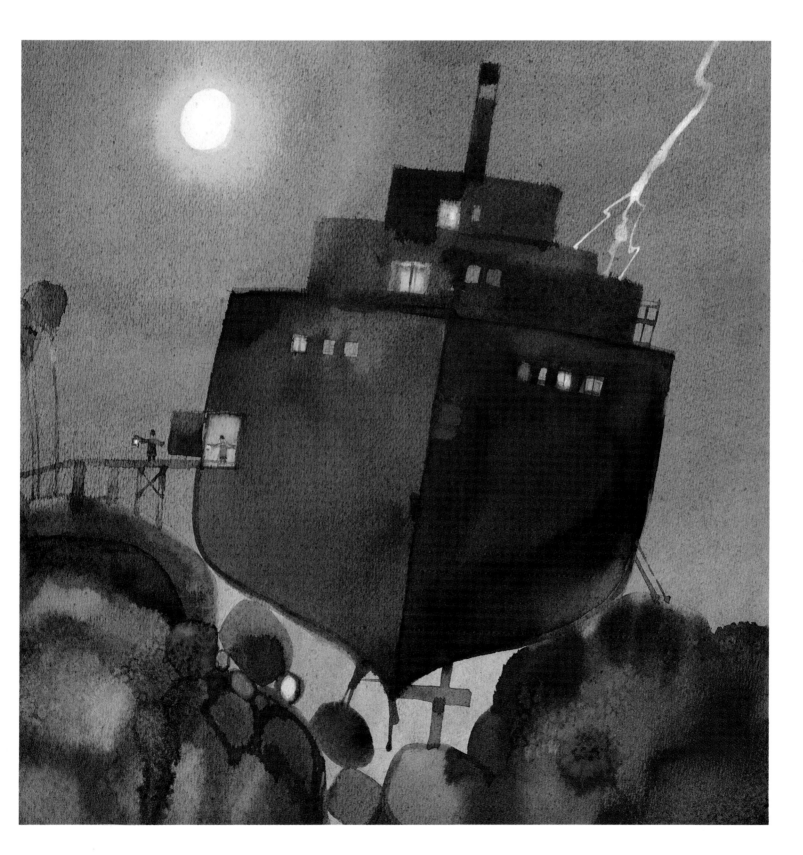

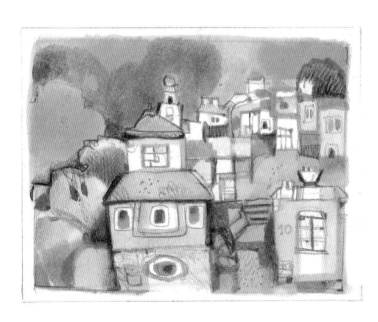

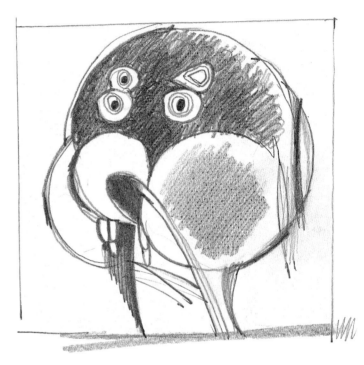

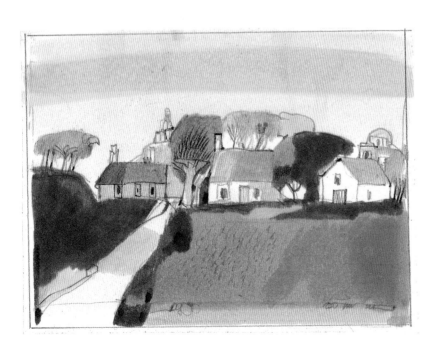

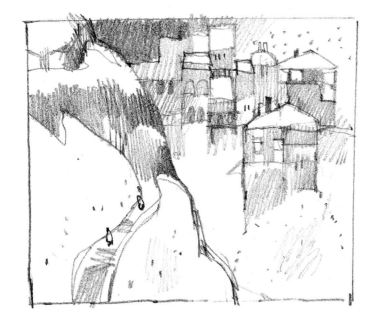

BILDBESCHREIBUNG
Umschlag: Mexikanischer Poster / Aquarell, 22 x 28cm, 1991
1 Aquarell, 17 x 8cm
2 Aquarell, 9 x 9cm
3 Landschaft im Herbst / Aquarell, 18 x 22cm
4 Der Wächter / Buntstift, 24 x 13cm
5 Jenseits / Bleistift und Graphit, 35 x 50cm
6 Wald in Blau / Aquarell und Buntstift, 9 x 23cm
7 Landschaft / Aquarell und Pastell, 35 x 40cm
8 Zeichnung, Bleistift, 10,5 x 12cm
9 Landschaft / Aquarell und Pastell, 35 x 40cm
10 Das Haus am Ende der Strasse / Aquarell und Buntstift
 auf Leinwand, 30 x 40cm
11 Tirnovo / Aquarell und Buntstift, 12 x 14cm
12 Dampfeisenbahn / Buch; Acryl, 19,5 x 21cm
13 Ivan Gantschev mit seiner Katze
14 Ivan Gantschev und seine Frau
15 Das Haus / Aquarell, 9 x 19cm
16 Ivan Gantschev als Siebenjähriger mit dem Auto
 seines Vaters
17 Ivan Gantschev auf der Frankfurter Buchmesse
18 Landschaft / Aquarell und Buntstift, 14 x 18cm
19 Viva la Mexiko / Buntstift, 24 x 13cm
20 Der Berg / Aquarell, 24 x 20cm
21 Am Ende der Welt / Aquarell und Buntstift, 16 x 20cm
22 Rudolph II. / Buntstift, 18 x 16cm
23 Amigo mio Amigo / Bleistift, 9 x 9cm
24 La Primadonna / Bleistift, 8,5 x 9cm
25 Landschaft / Aquarell und Buntstift, 28 x 35cm
26 Herbst / Aquarell-Stift, 21 x 30cm
27 Irgendwo / Pastell und Aquarell, 30 x 40cm
28 Ich, Hortensia / Buntstift, 5 x 6,5cm
29 Bäume am Fluss / Aquarell und Pastell, 15 x 19cm
30 Bleistiftzeichnung, 15 x 18cm
31 Ivan, der Vulkan / Buch; Mischtechnik, 16,5 x 20cm
32 Aquarell, 15 x 18cm
33 Ivan, der Vulkan / Buch; Mischtechnik, 15 x 17cm
34 Das Dorf / Acryl, 25 x 19cm
35 Hinaus in den Ozean / Aquarell, 10 x 14cm
36 Der Berg / Buntstift auf Leinwand, 11 x 14cm
37 Die Katze / Buntstift auf Leinwand, 13,5 x 16cm
38 Herbst / Aquarell, 16 x 20cm
39 Landschaft / Buntstift, 17 x 19cm
40 Der Wald / Aquarell, 18 x 20cm
41 Der Fremde / Buch; Aquarell, 21 x 27cm
42 Der Baum der Lüste / Bleistift, 32 x 55cm
43 Landschaft / Aquarell, 9 x 11cm
44 Landschaft / Aquarell, 9 x 13cm
45 Mein Geburtstagsbuch / Buch; Aquarell, 14 x 15cm
46 Gute Nacht, Anna / Buch; Aquarell, 22 x 18,5cm
47 Mexiko / Mischtechnik, 20 x 18cm
48 Ivan, der Vulkan / Buch; Aquarell, 49 x 29cm
49 Der Fremde / Buch; Aquarell, 21 x 27cm
50 Der Wald / 14 x 17cm
51 Ivan, der Vulkan / Buch; Aquarell, 43 x 29cm
52 Der Mondsee / Buch; Aquarell, 29 x 43cm
53 Einsam / Aquarell, 10 x 16,5cm
54 Herbst / Aquarell, 30 x 40cm
55 Kanufahrt / Buch; Aquarell, 26 x 43cm
56 Stadt am Fluss / Tempera, 15 x 18cm
57 Der Fremde / Buch; 21 x 27cm
58 Kanufahrt / Buch; Aquarell, 29 x 43cm
59 Mexiko / Tempera, 15,5 x 17,5cm
60 Die Geschwister / Aquarell, 21 x 27cm
61 Jakob, der Storch / Buch; Aquarell, 26 x 43cm
62 Der Mondsee / Buch; Aquarell, 29 x 43cm
63 Ivan, der Vulkan / Buch; Aquarell, 20 x 26cm
64 Ivan, der Vulkan / Buch; Aquarell, 18,5 x 26cm
65 Ivan, der Vulkan / Buch; Aquarell, 29 x 45cm
66 Der Fremde / Buch; Aquarell, 21 x 27cm
67 Der Fremde / Buch; Aquarell, 33 x 45cm
68 Hallo Bär / Buch; Aquarell, 35 x 36cm
69 Frohe Weihnachten / Buch; Aquarell, 25 x 18cm
70 Die grüne und die graue Insel / Buch; Aquarell, 33 x 43cm
71 Jakob, der Storch / Buch; Aquarell, 33 x 43cm
72 Guten Morgen–Gute Nacht / Buch; Aquarell, 33 x 43cm
73 Guten Morgen–Gute Nacht / Buch; Aquarell, 33 x 43cm
74 Der Philosophenberg / Aquarell, 8 x 6cm
75 Hallo Bär /Buch; Aquarell, Ausschnitt
76 Hallo Bär / Buch; Aquarell, 37 x 36cm
77 Der Fremde /Buch; Aquarell, 21 x 27cm
78 Guten Morgen–Gute Nacht / Buch; Aquarell, 23 x 43cm
79 Der Weihnachtsteddybär / Buch; Aquarell, 22 x 25cm
80 Wo ich geboren bin / Buch; Aquarell, 38 x 48cm
81 Der Fremde / Buch; Aquarell, 34 x 45cm
82 Der Weihnachtsteddybär / Buch; Aquarell, 22 x 24cm
83 La Citta / Tempera und Aquarell, 28 x 24cm
84 Der Weihnachtsteddybär / Buch; Aquarell, 22 x 24cm
85 Wo wohnt mein Glück / Buch; Aquarell, 26 x 32cm
86 Die Arche Noah / Buch; Aquarell, 22 x 23cm
87 Skizzen, Buntstift und Bleistift
88 Skizzen, Bleistift
89 Die grüne und die graue Insel / Buch; Aquarell, Ausschnitt
90 Der Weihnachtszug / Buch; Aquarell, 17 x 25cm
91 Ich bin da! / Bleistiftzeichnung, 9 x 11cm

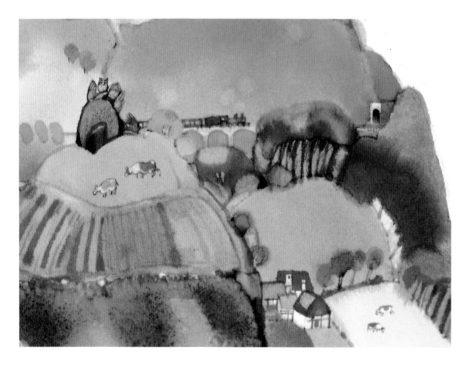

89 Two Islands / Book Illustration / watercolour

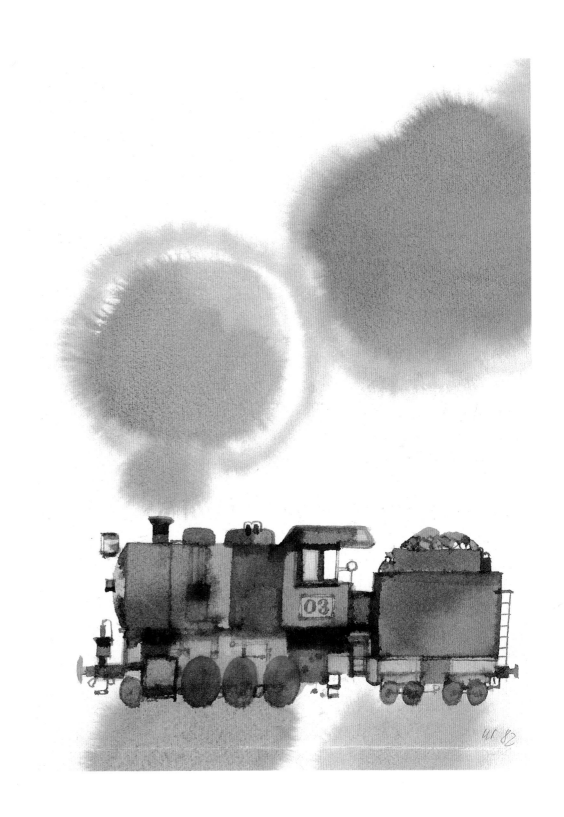

91 I AM HERE! / pencil drawing, 9 x 11cm